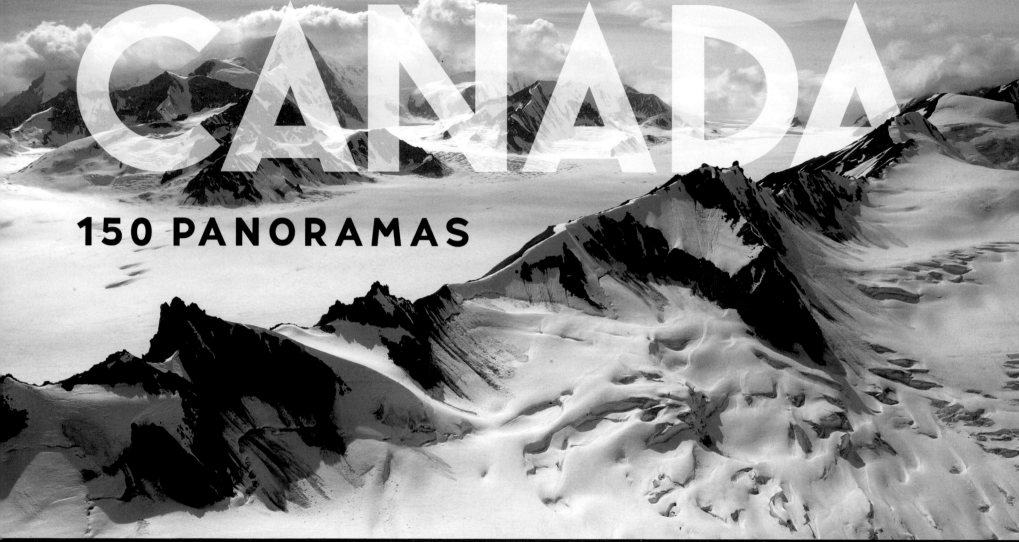

CANADA

150 PANORAMAS

GEORGE FISCHER

NIMBUS
PUBLISHING LTD

nimbus.ca

CANADA 150

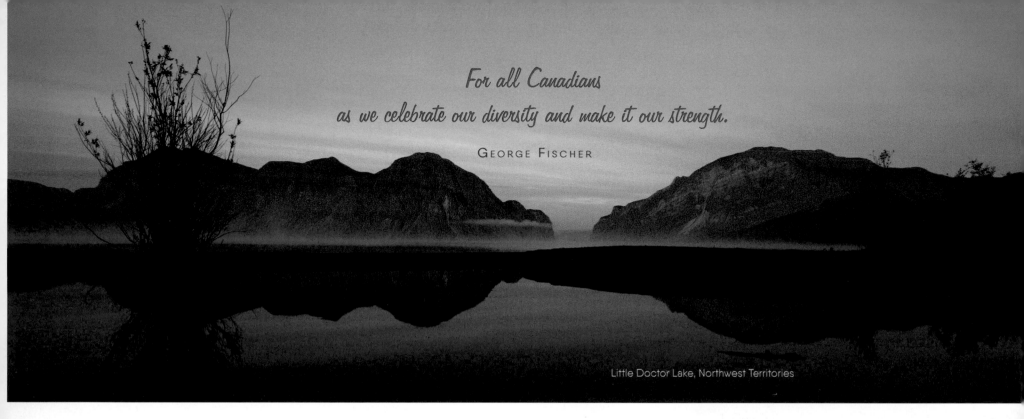

*For all Canadians
as we celebrate our diversity and make it our strength.*

GEORGE FISCHER

Little Doctor Lake, Northwest Territories

Design, text and captions by Catharine Barker – National Graphics, Toronto, ON Canada
Photo credit p. 62: Catharine Barker

Nimbus Publishing Limited
PO Box 9166, Halifax, NS Canada B3K 5MB
Tel.: 902-455-4286

Printed in Canada

NB1294

COVER PAGE: Lighthouse at l'Étang-du-Nord, Îles de la Madeleine, Québec
TITLE PAGE: St. Elias Range, Kluane National Park and Reserve, Yukon

Library and Archives Canada Cataloguing in Publication

Fischer, George, 1954-, photographer, author
Canada : 150 panoramas / photos, George Fischer.

ISBN 978-1-77108-487-1 (hardcover)

1. Photography, Panoramic—Canada. 2. Landscape photography—Canada. 3. Canada—Pictorial works. I. Title.

FC59.F56 2017 971.0022'2 C2016-908043-9

Nimbus Publishing acknowledges the financial support for its publishing activities from the Government of Canada through the Canada Book Fund (CBF) and the Canada Council for the Arts, and from the Province of Nova Scotia. We are pleased to work in partnership with the Province of Nova Scotia to develop and promote our creative industries for the benefit of all Nova Scotians.

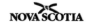

Canada

Canada Council Conseil des arts
for the Arts du Canada

NOVA SCOTIA

TABLE OF CONTENTS

CANADA

Baffin Bay

Arctic Ocean

Atlantic Ocean

Pacific Ocean

• Dawson

**YUKON
TERRITORY**

**NORTHWEST
TERRITORIES**

NUNAVUT

• Whitehorse

• Yellowknife

Iqaluit •

Ivujivik •

Happy Valley
–Goose Bay •

**NEWFOUNDLAND
& LABRADOR**

**BRITISH
COLUMBIA**

ALBERTA

Hudson Bay

QUÉBEC

St. John's •

Haida
Gwaii

Fort McMurray •

SASKATCHEWAN

*Gulf of
St. Lawrence*

Port aux Basques •

Prince George •

MANITOBA

Îles-de-la-Madeleine •

Edmonton •

• Saskatoon

ONTARIO

La Malbaie •

Gaspé

**PRINCE
EDWARD ISLAND**

Kamloops •

Moncton •

Charlottetown •

Vancouver
Island

Banff •

Fredericton •

Bay of Fundy

Vancouver •

• Calgary

• Winnipeg

• Timmins

Québec City •

**NEW
BRUNSWICK**

Halifax •

NOVA SCOTIA

Victoria •

Regina •

Brandon •

Thunder Bay •

Lake Superior

Sudbury •

North Bay •

*Lake
Nipissing*

Montréal •

Atlantic Ocean

✪ Ottawa

Toronto •

Lake Huron

Lake Ontario

Niagara Falls •

Lake Michigan

London •

Windsor •

Lake Erie

St. Lawrence River

If you think you know Canada, it may be time to think again. The immense size of the country would ask for a two-week drive across the 7,821-kilometre Trans-Canada Highway, one way – but of course that would only scratch the surface. The trails and attractions, the natural grandeur and the history beg for more contemplation. Celebrating Canada's 150th birthday is the perfect chance to look more deeply into what the country has to offer.

Canada's 150th marks Confederation; however, the First Nations people have inhabited this land for thousands of years. Europeans came in the sixteenth century and through conflict and pioneering the colony of Canada – and then the dominion – eventually gave way to independence from Great Britain with the British North America Act, passed on July 1, 1867.

Travelling on and off the beaten track, George Fischer has put together a compilation of highlights in appreciation of Canada's incredible offerings, arranged by province and territory. His love for the nation has led to snowmobile rides capturing polar bear images in Nunavut to a hired fishing boat chasing down icebergs in Newfoundland and Labrador. A stop in the Northwest Territories turned into an incredible venture in and around the Nahanni National Park Reserve and he has visited the unique Thousand Islands region of Ontario in all seasons and from many vantage points. From the Pacific to the Atlantic – from the Arctic to the Great Lakes and Middle Island (the nation's southernmost point) – breathtaking panoramas are showcased in the pages that follow.

Celebrating the past while embracing the present is a Canadian trait. Multicultural and multilingual, the country celebrates diversity. People from many cultures come together to call Canada home and this contrast is the foundation of our national unity. Good-naturedly aware of stereotypes as polite, hockey-playing maple-syrup eaters, Canadians can laugh off the jokes while sipping on a Tim's double-double because they know it's the best country in which to live. From the majestic mountains and the far reaches of the north, where you can still feel the raw energy of nature, to the crashing ocean waves, calm lakes, and warm beaches, the images in this book capture the essence of Canada's beauty.

CA PREFACE

From sea to sea

Capital: Ottawa

National Symbol: Maple leaf

Interesting Fact: Canada has the world's largest proportion of freshwater lakes in its 9.98 million-square-kilometre area.

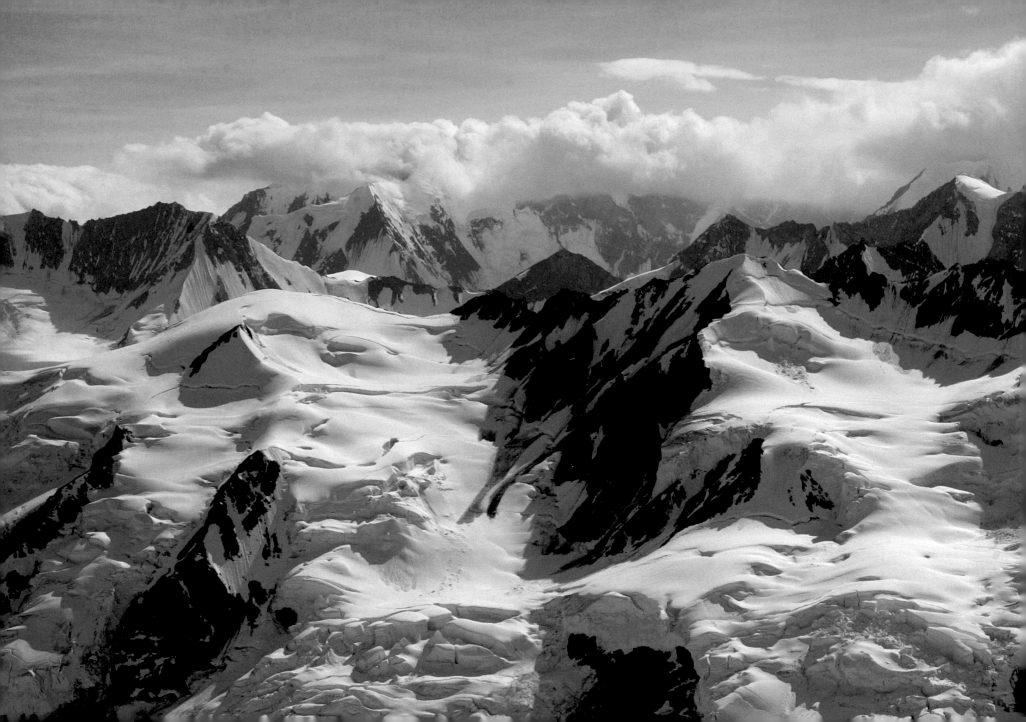

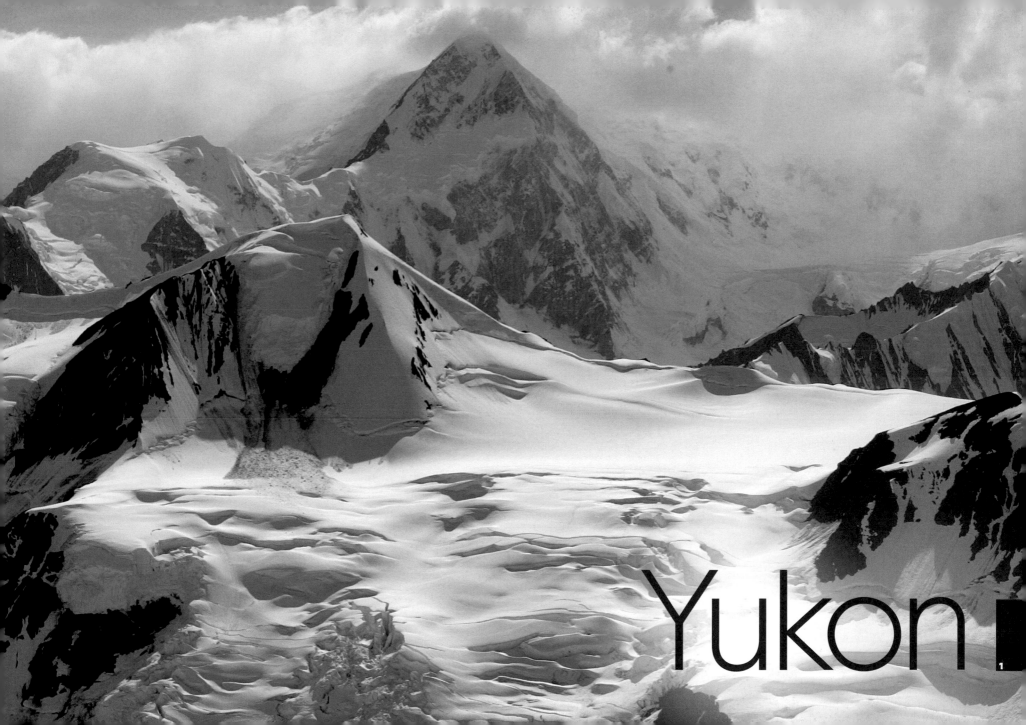

Yukon

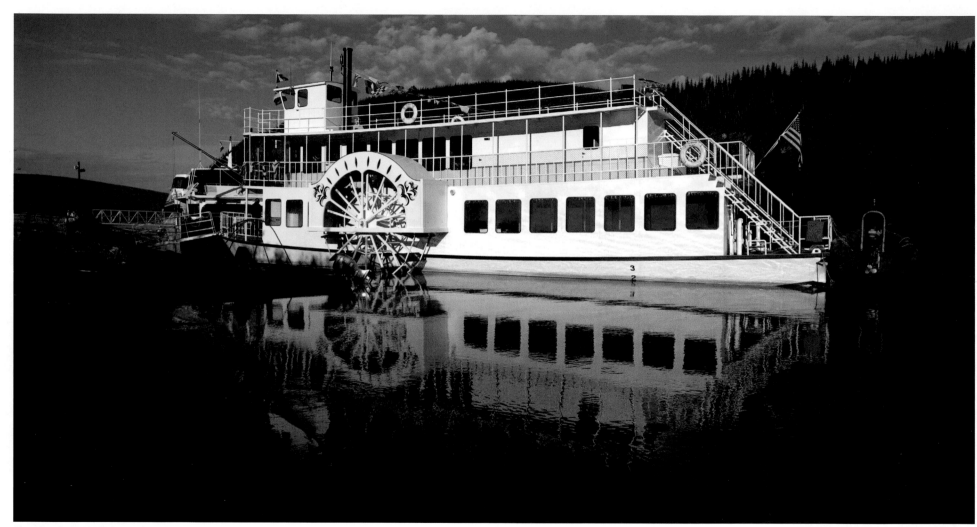

Klondike Spirit, Whitehorse, Yukon

Rugged mountains, boreal forest, and alpine tundra marked by glacier-fed lakes make up Canada's westernmost territory. Its name, meaning "Great River" from the Locheux people, lays claim to Mount Logan, which towers over the Kluane National Park and Reserve (a UNESCO World Heritage Site). This unique corner of the nation boasts unforgettable wild beauty and conjures thoughts of the Klondike Gold Rush in 1897 and the rough days of the fur trade.

First Nation communities called Yukon home long before prospectors, missionaries, traders, or European explorers arrived. In fact, some of the earliest evidence of human settlement in North America is protected here on archaeological sites. Ancient geological evidence tells us that a good part of the territory escaped the last ice age. Beringia, a land bridge stretching to Siberia, created an access between continents lessening the degrees of separation in species across the globe. Picture black bears and camels, moose and woolly mammoths migrating to new environs.

Today migration comes in the form of tourism. Sunny, warm summers with 20 hours of daylight bring cyclists and backpackers eager to find nature and pristine conditions. Crisp winters bring the thousand-mile "Yukon Quest" dogsled race and plenty of excitement. The daylight may be brief during colder months, averaging 6.5 hours daily, but that allows more chance to see the dancing northern lights. No matter what season, Yukon will capture a part of your heart.

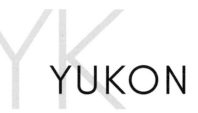

YUKON

The Klondike

Territory since 1898

Capital: Whitehorse

Flower: Fireweed

Interesting Fact: At 5,959 metres above sea level, Mount Logan of the St. Elias Mountains in Kluane National Park is the highest point in Canada.

PREVIOUS SPREAD: Mount Logan, Kluane National Park and Reserve, Yukon

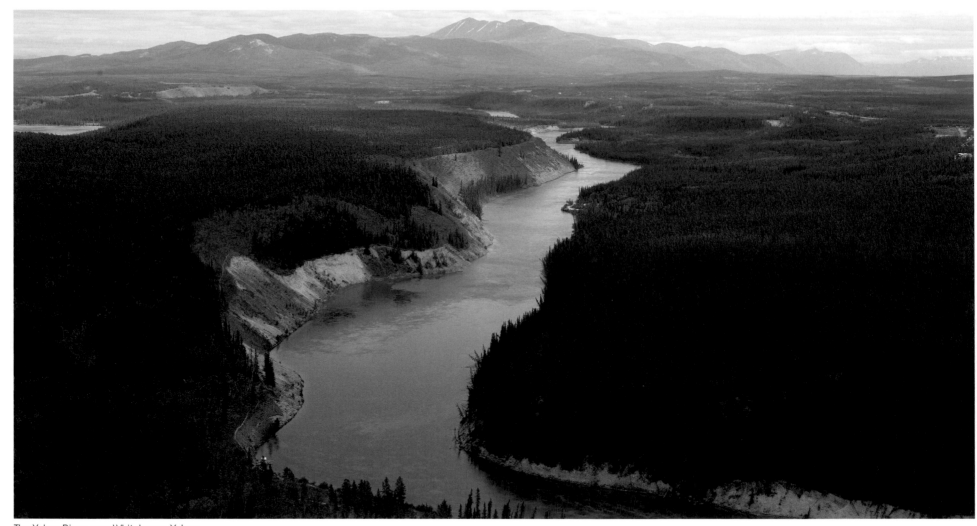

The Yukon River, near Whitehorse, Yukon

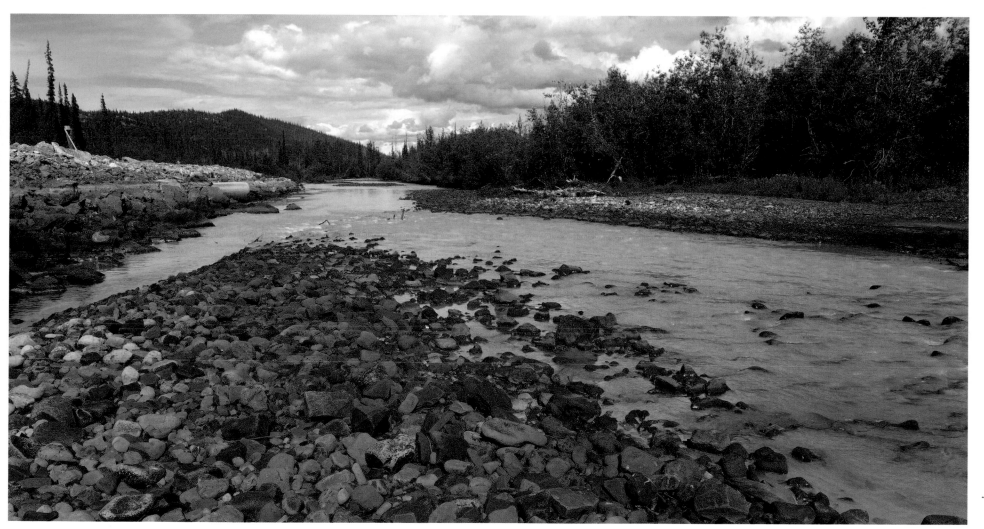

Near the Dempster Highway, Yukon

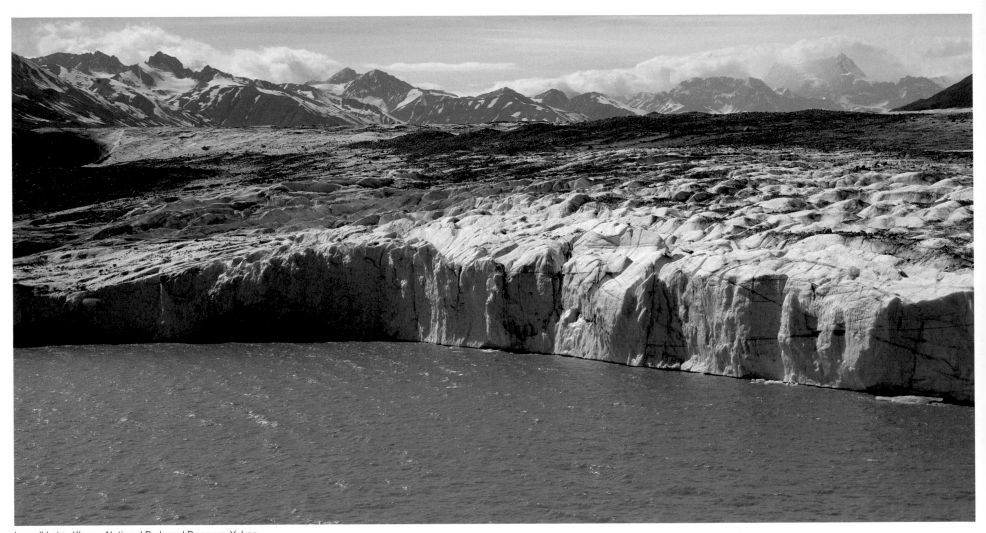

Lowell Lake, Kluane National Park and Reserve, Yukon

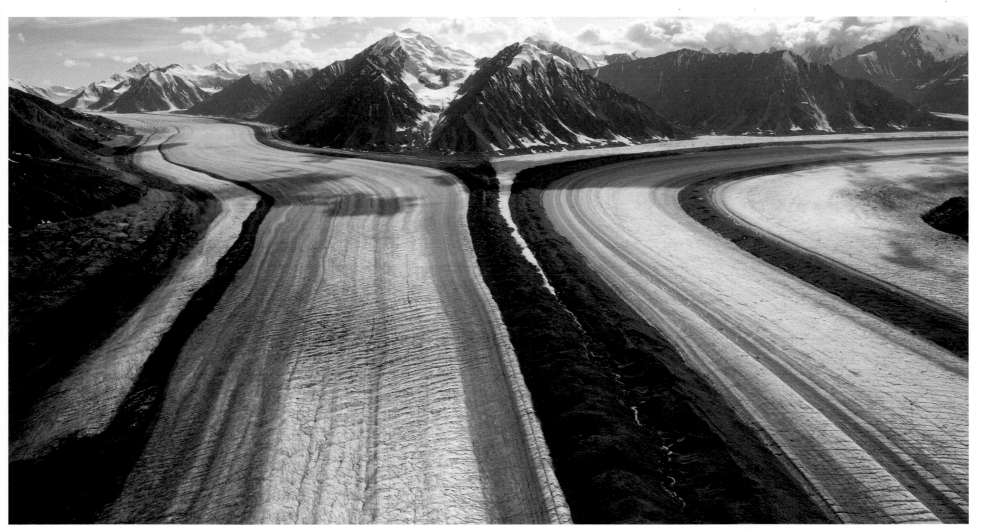

Kaskawulsh Glacier, Kluane National Park and Reserve, Yukon

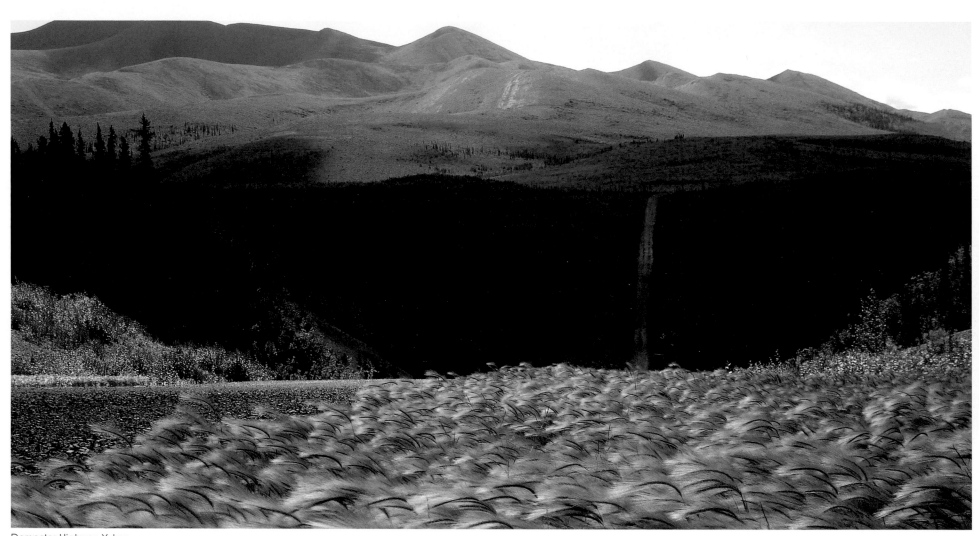

Dempster Highway, Yukon

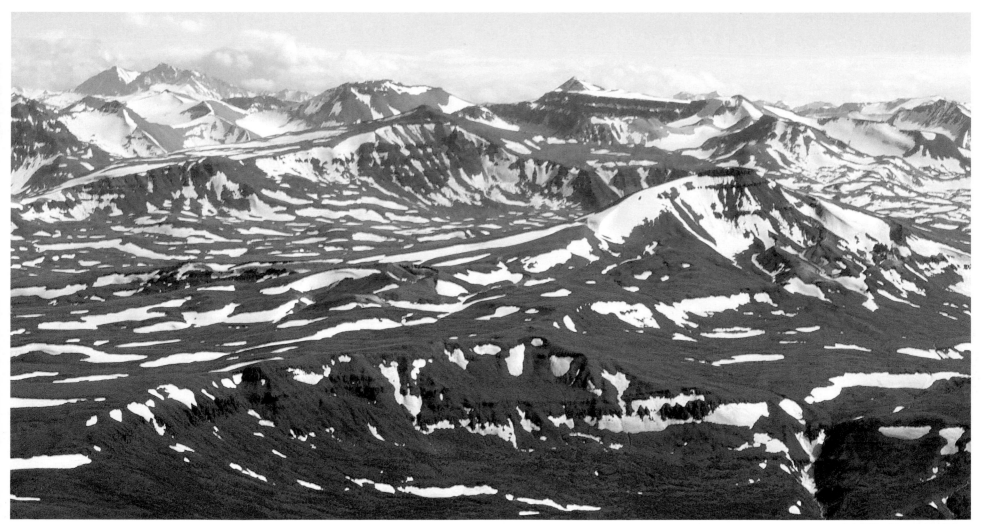

Saint Elias Mountains, Yukon

PREVIOUS SPREAD: Near Dawson City, Yukon

British Columbia

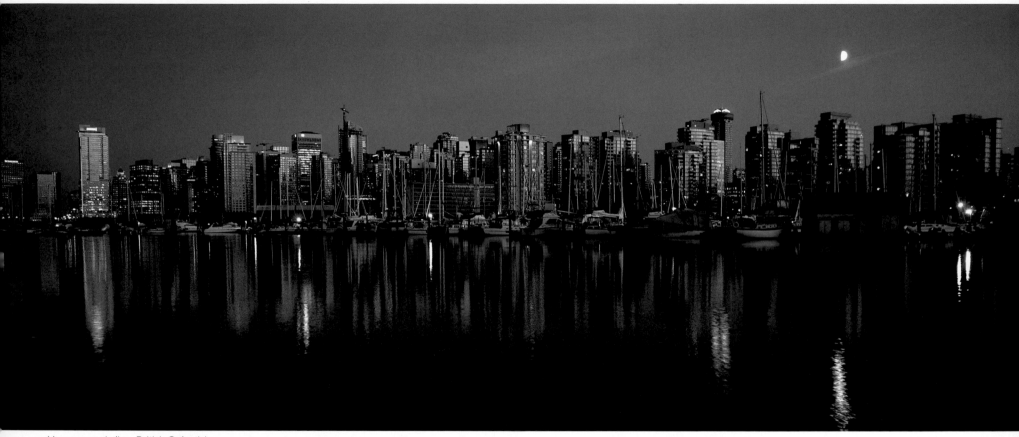

Vancouver skyline, British Columbia

To be complex does not mean to be fragmented.
This is the paradox and the genius of our Canadian civilization.
ADRIENNE CLARKSON, FORMER GOVERNOR GENERAL OF CANADA

Sitting in the southwest corner of Canada and bordered on one side by the Pacific Ocean, British Columbia has it all: incredible mountain range vistas with clear streams and unbelievably ancient forests are nestled close to vibrant cities with world-renowned resorts and exciting festivals. Towering mountain systems (BC has ten), soft grasslands, and robust forests are woven with lakes, streams, and marshes and decorated with flora and fauna – all creating an abundant ecosystem. Ample natural resources have driven the economy, but breathtaking panoramas serve as inspiration for locals and visitors alike.

Incredibly, there's more. Haida Gwaii, an archipelago off BC's north coast, is a destination in itself. This group of islands boasts a rich mixture of history and nature. A culture that dates back to before European contact is part of the allure. Articulated by its unique lifestyle, visitors are privileged to get a glimpse of the past, meet people in the community, and view local art. A good place to check off the bucket list is Gwaii Haanas National Park – part of the reason the area is known as Canada's Galapagos. Totem poles, the Haida Gwaii Watchmen, hotsprings, and distinct flora and fauna all contribute to the appeal.

A new adventure around every corner will make you fall in love with "Beautiful British Columbia." From rocky peaks to the verdant valleys of wine country, oceanside beaches and remarkable parks, prepare to be exhilarated.

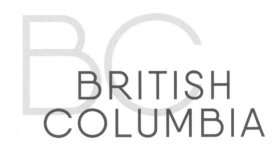

BRITISH COLUMBIA

Canada Starts Here

Joined confederation in 1871

Capital: Victoria

Flower: Pacific dogwood

Interesting Fact: The western red cedar "Hanging Garden Tree" on Meares Island in Tofino has a circumference of 18.3 metres and is believed to be 1,500–2,000 years old.

PREVIOUS SPREAD: Lina Island on the Skidegate Inlet, British Columbia

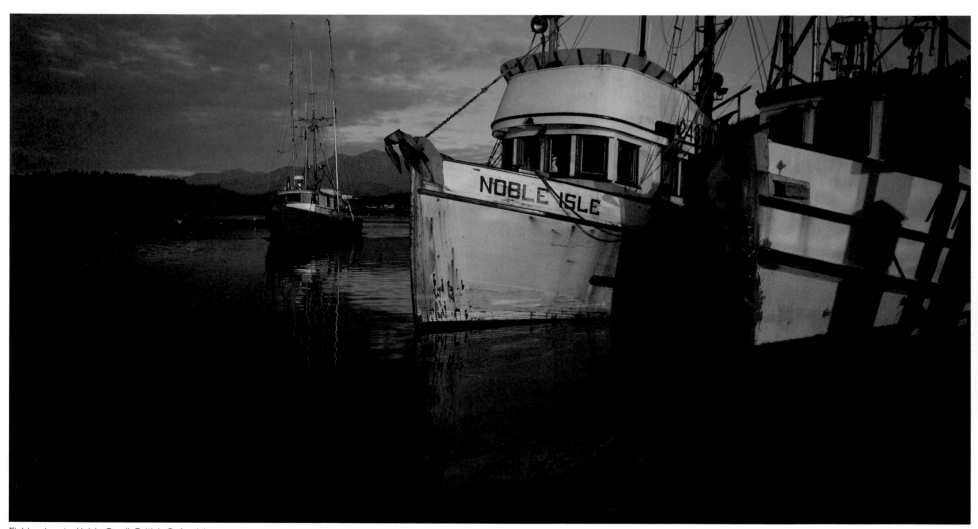

Fishing boats, Haida Gwaii, British Columbia

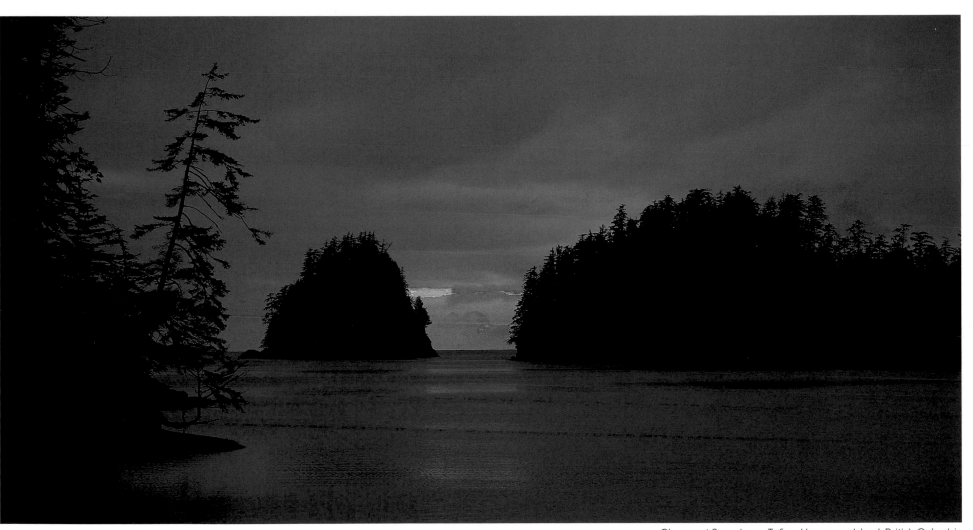

Clayoquot Sound near Tofino, Vancouver Island, British Columbia

Killer whale, Juan Perez Sound, Haida Gwaii, British Columbia

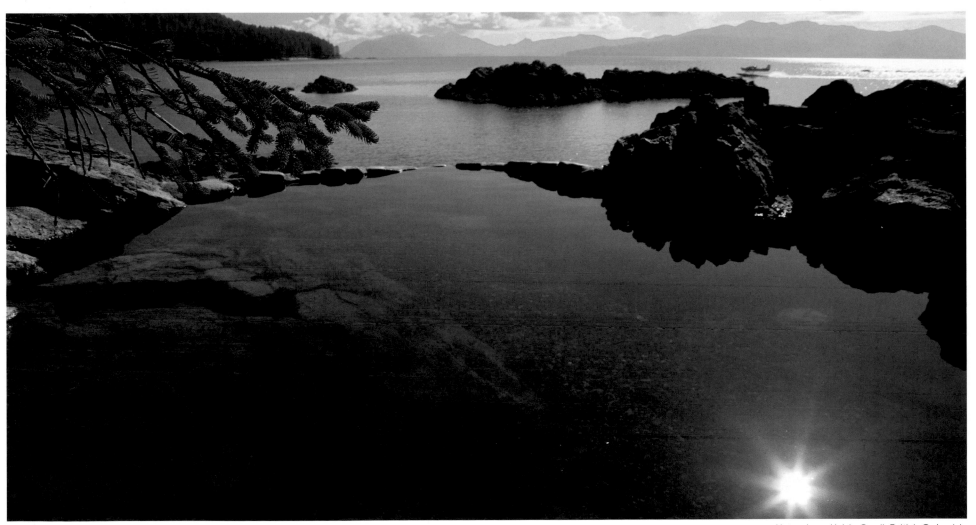

Hotsprings, Haida Gwaii, British Columbia

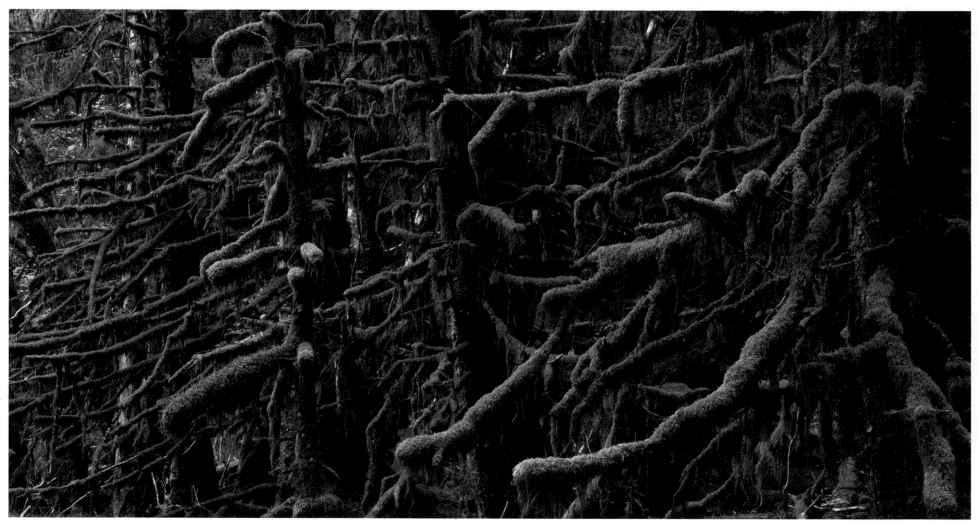

Rainforest, Haida Gwaii, British Columbia

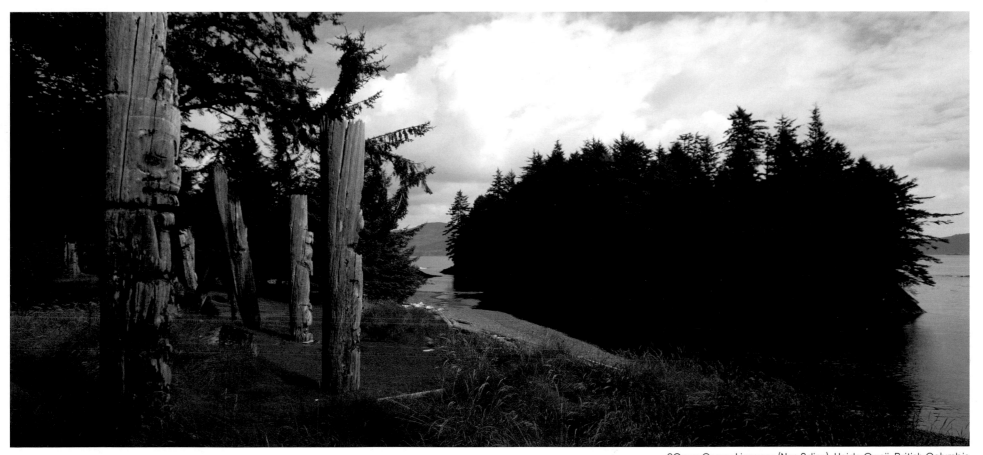

SGang Gwaay Linagaay (Nan Sdins), Haida Gwaii, British Columbia

It is wonderful to feel the grandness of Canada in the raw, not because she is Canada but because she's something sublime that you were born into, some great rugged power that you are a part of.

EMILY CARR, ARTIST AND WRITER

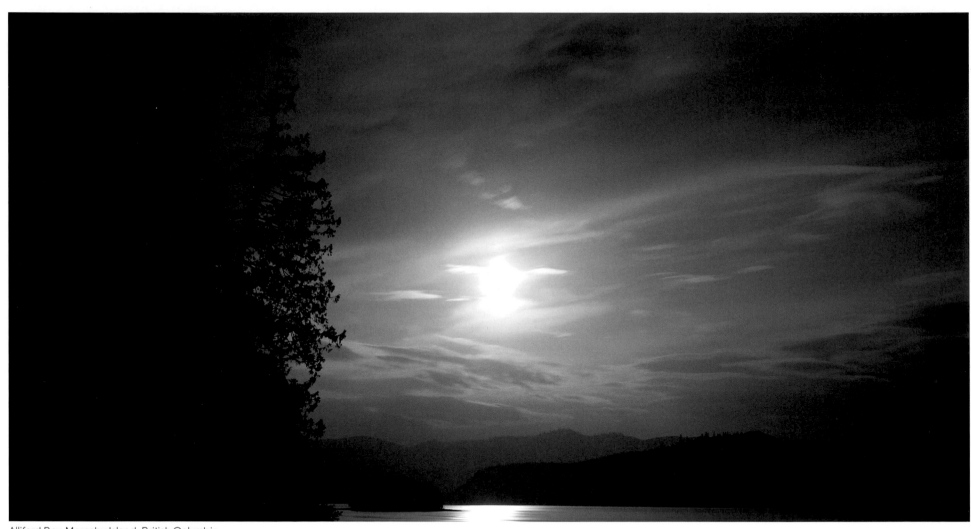

Alliford Bay, Moresby Island, British Columbia

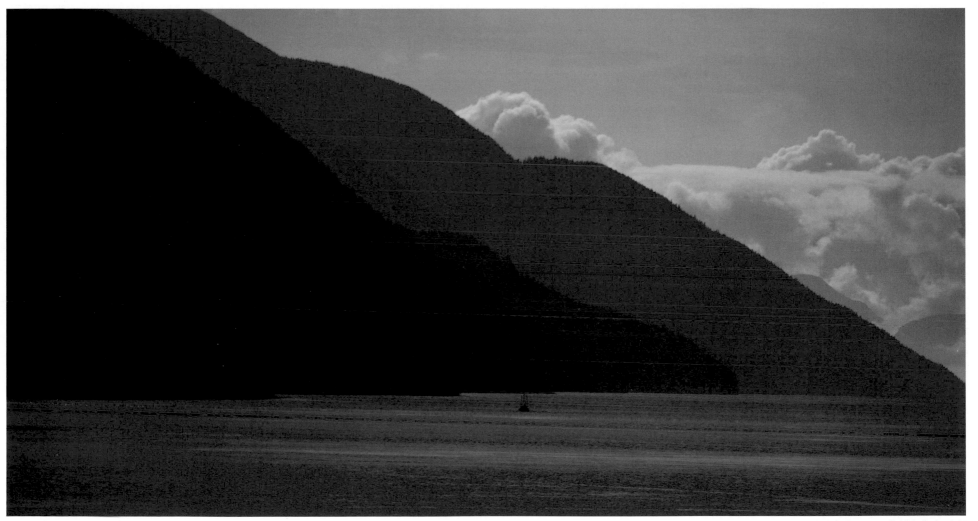

Inside Passage, British Columbia

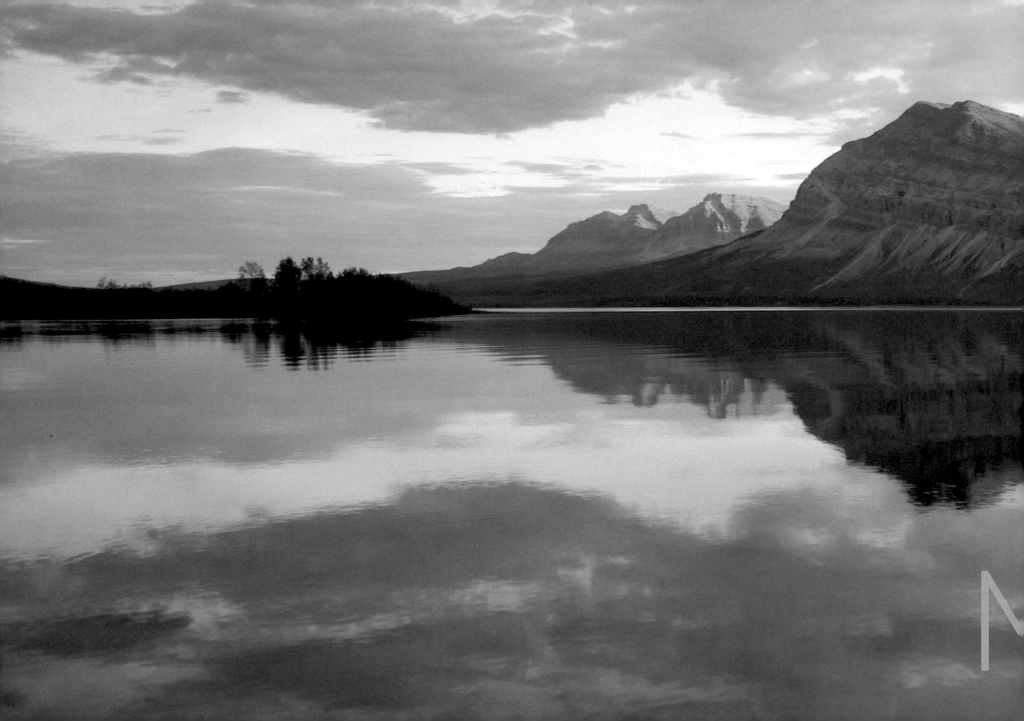

25

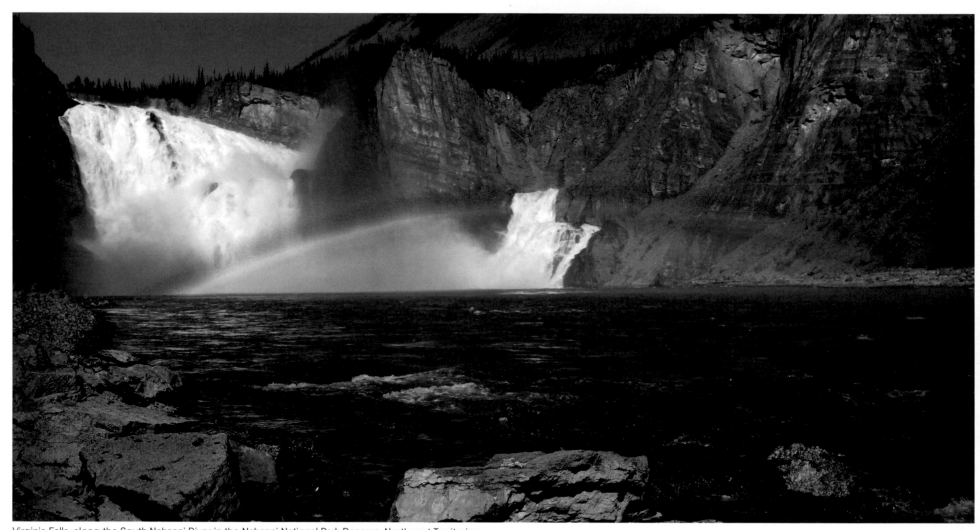

Virginia Falls, along the South Nahanni River in the Nahanni National Park Reserve, Northwest Territories

The expansive reaches of Canada's north are enjoying a rising interest as people seek adventure – one of the fastest growing segments of the tourism industry. This is certainly true of the Northwest Territories and the regions of Dehcho, North Slave, Sahtu, South Slave, and Inuvik that it encompasses.

Under British authority in 1870, the land – known then as the North-Western Territory – was transferred to Canada by the Crown and comprised most of what we know as today's Canada. Subsequent years saw provinces and borders shift; most recently in 1999 when the eastern three-fifths of the Northwest Territories was designated as the new territory of Nunavut. Today, remote northern communities offer a glimpse of fascinating culture with a warm welcome.

Savvy visitors to the Northwest Territories realize that all seasons bring an incredible wealth of diverse experiences. Outfitters help facilitate tours to explore pristine wilderness while hikers, canoers, and kayakers challenge obscure trails and mighty rivers, and mountain-climbers confront world-class peaks. Crisp, clear winter nights bring the incredible phenomenon of the Aurora Borealis – the dancing northern lights.

Wood Buffalo National Park (protecting the last remaining herds of bison in northern Canada) trails from the southern border right up from Alberta. Skip a bit further north and discover the Waterfalls Route where numerous lakes and rivers surge over thundering waterfalls. Sandy beaches and great fishing offer travellers the chance to slow down and unwind.

A must-see destination is the Nahanni National Park Reserve. Bush planes are the vehicle of choice to trek into remote regions of jagged peaks and lush valleys. Landing at the thundering Virginia Falls is an experience that won't be forgotten. Canoeists portage here while flight tours take to the skies and continue over Nahanni's awe-inspiring canyons and rushing rivers.

Wide-open spaces let visitors capture an untroubled moment and remind them of the sheer vastness of Canada. At every turn is a postcard-worthy view.

NT
NORTHWEST TERRITORIES

Spectacular Northwest Territories

Joined confederation in 1870

Capital: Yellowknife

Flower: Mountain avens

Interesting Fact: The Nahanni National Park Reserve was the world's first UNESCO heritage site. The park was expanded in 2009 from an area of 4,765 square kilometres to 30,050 square kilometres to include most of the Greater Nahanni ecosystem in the Dehcho region, and most of the South Nahanni River watershed.

PREVIOUS SPREAD: Little Doctor Lake, Northwest Territories

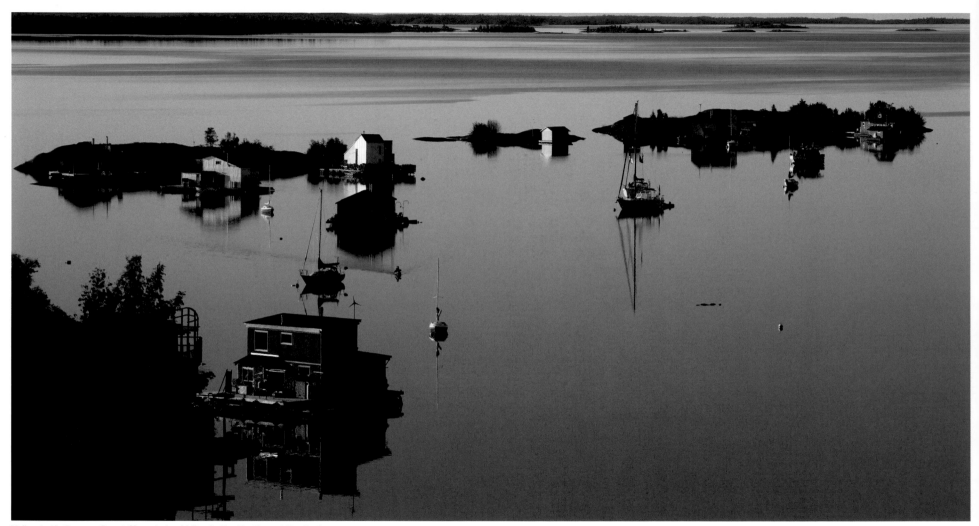

Yellowknife Bay on Great Slave Lake, Yellowknife, Northwest Territories

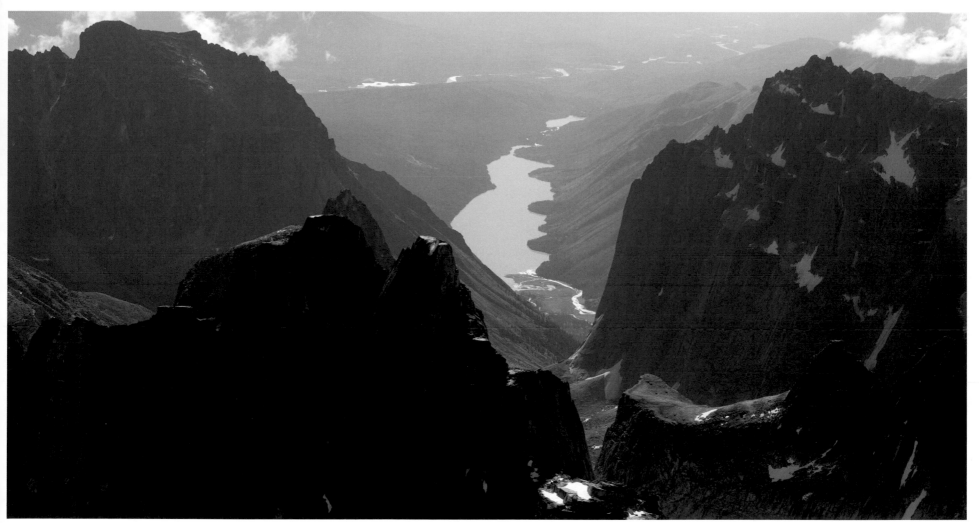
Glacier Lake, Nahanni National Park Reserve, Northwest Territories

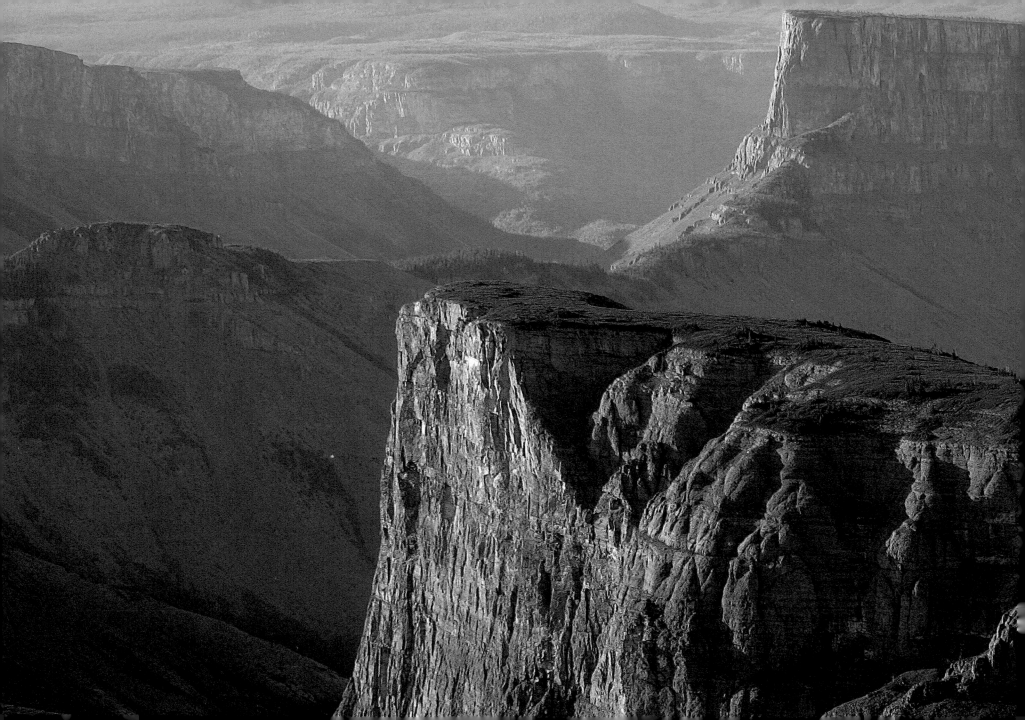

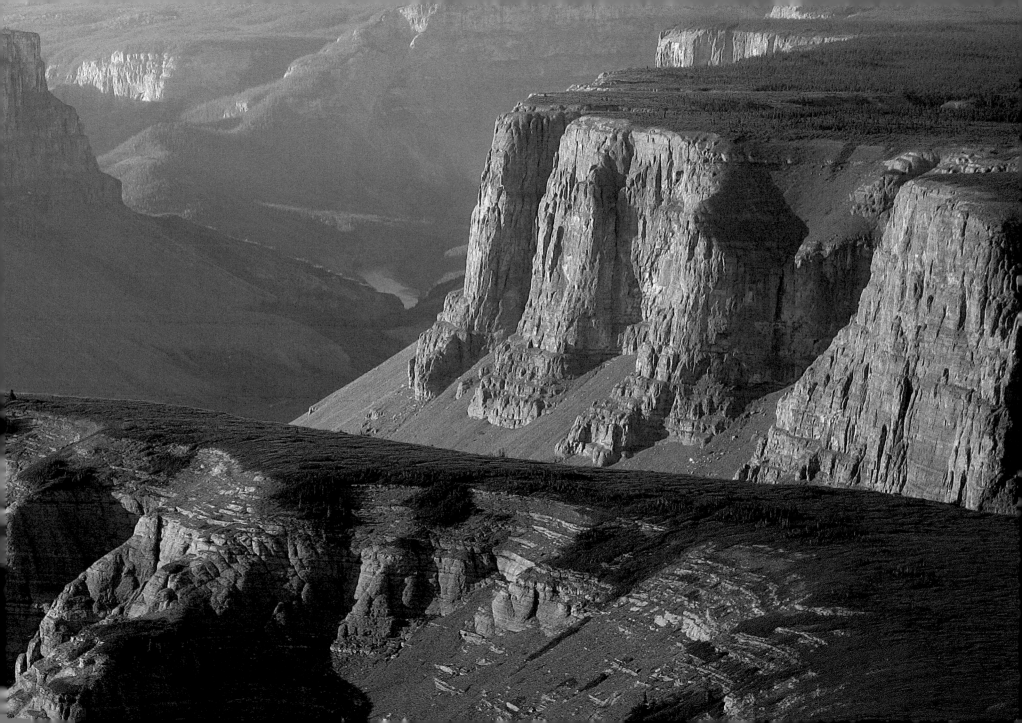

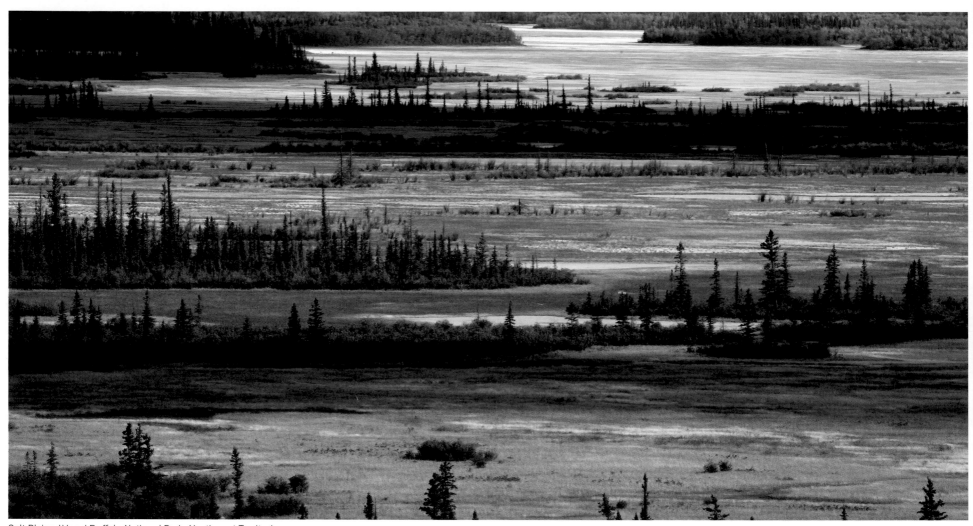

Salt Plains, Wood Buffalo National Park, Northwest Territories

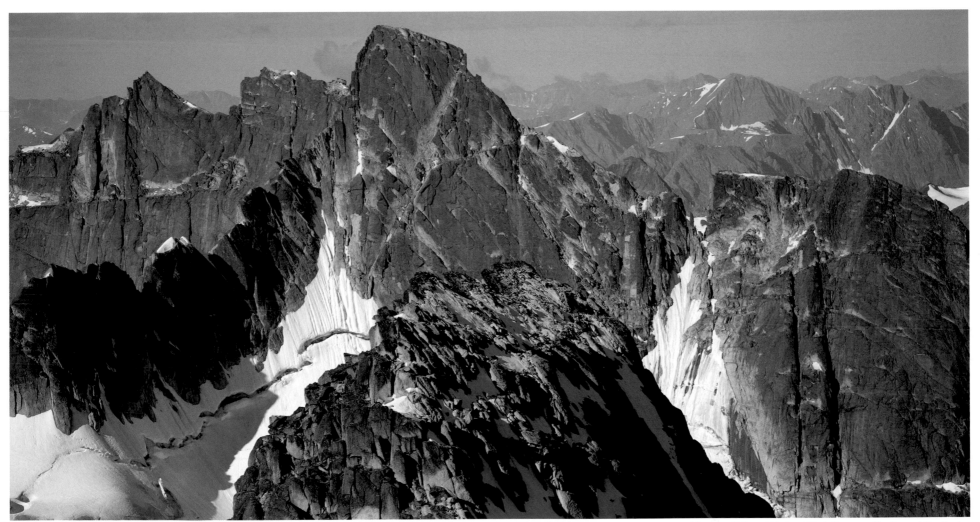

Cirque of the Unclimbables of the Ragged Range, Nahanni National Park Reserve, Northwest Territories

PREVIOUS SPREAD: Ram Plateau, Nahanni National Park Reserve, Northwest Territories

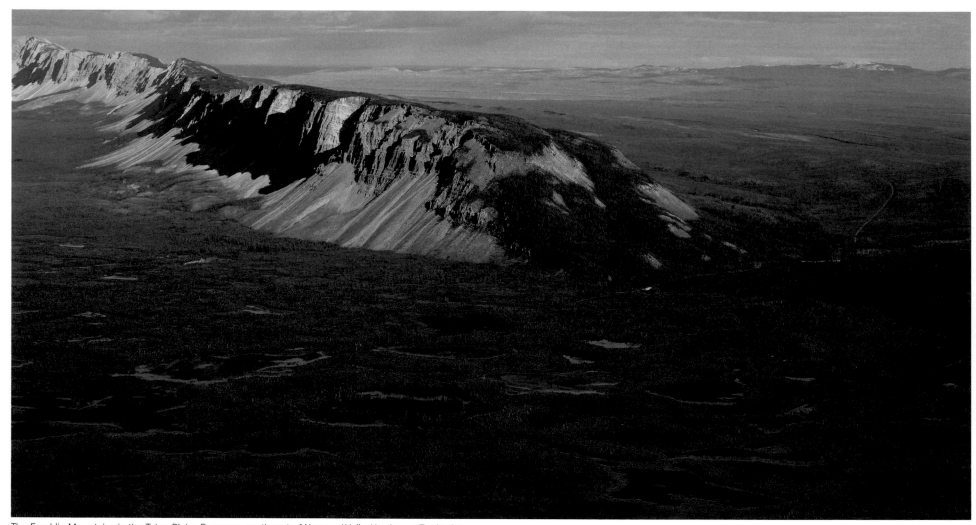

The Franklin Mountains in the Taiga Plains Ecozone, northeast of Norman Wells, Northwest Territories

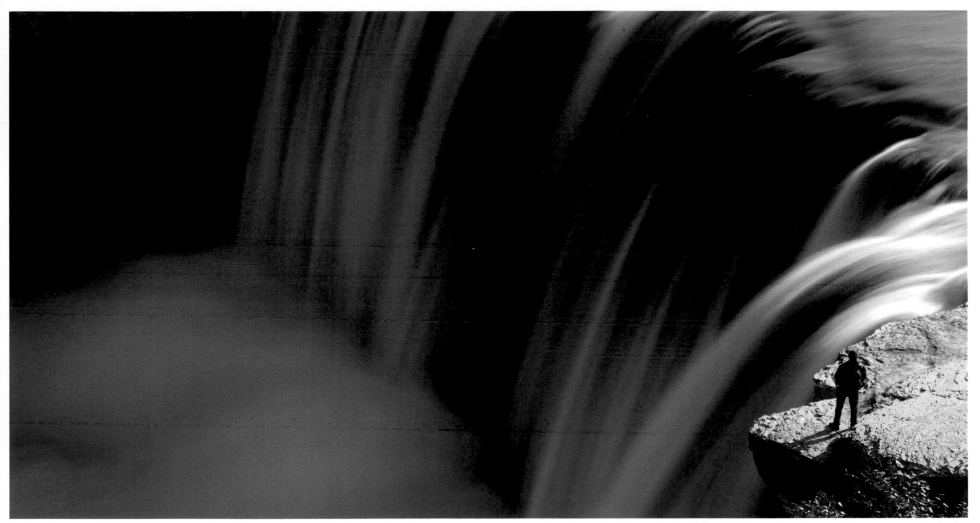

Alexandra Falls, Twin Falls Gorge Territorial Park, Northwest Territories

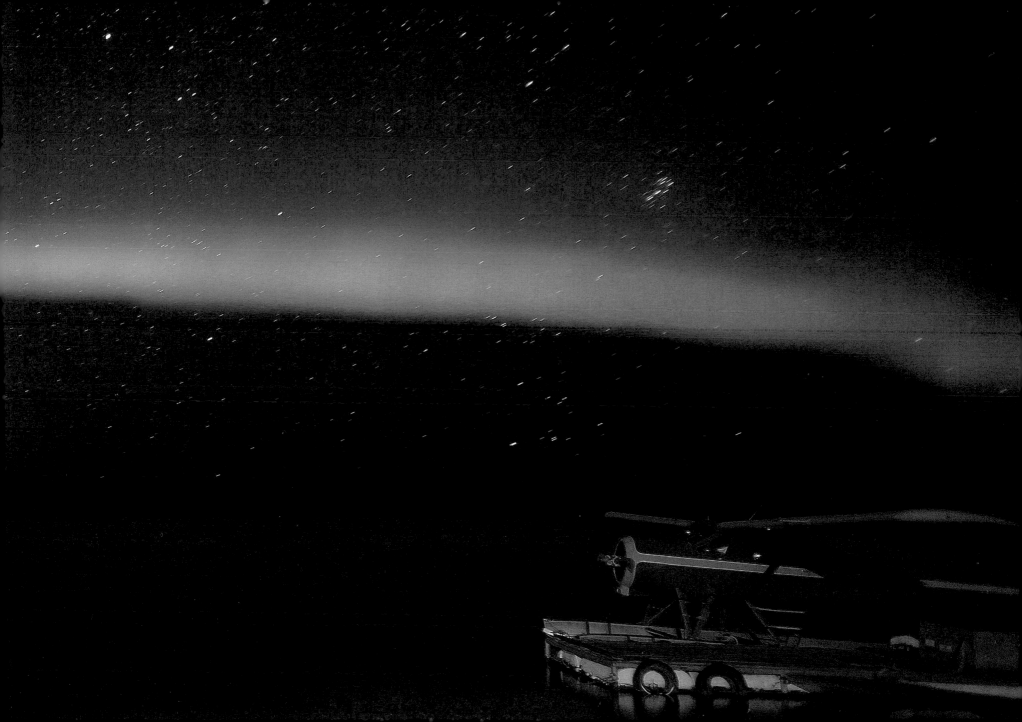

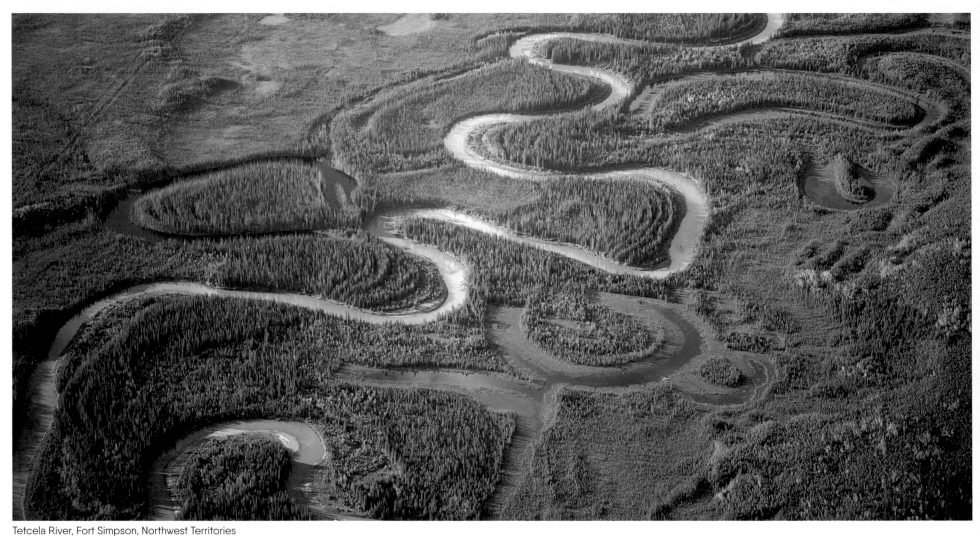

Tetcela River, Fort Simpson, Northwest Territories

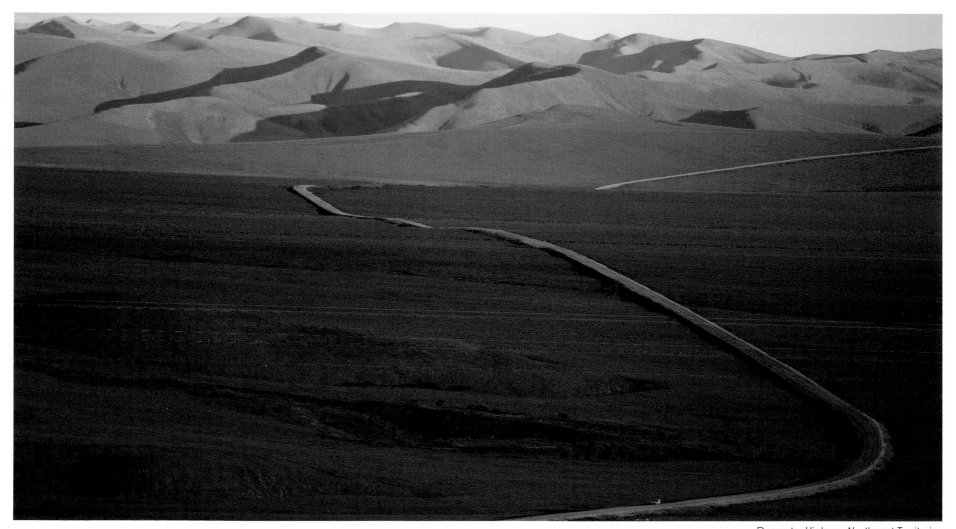

Dempster Highway, Northwest Territories

PREVIOUS SPREAD: The Aurora Borealis, Fort Simpson, Northwest Territories

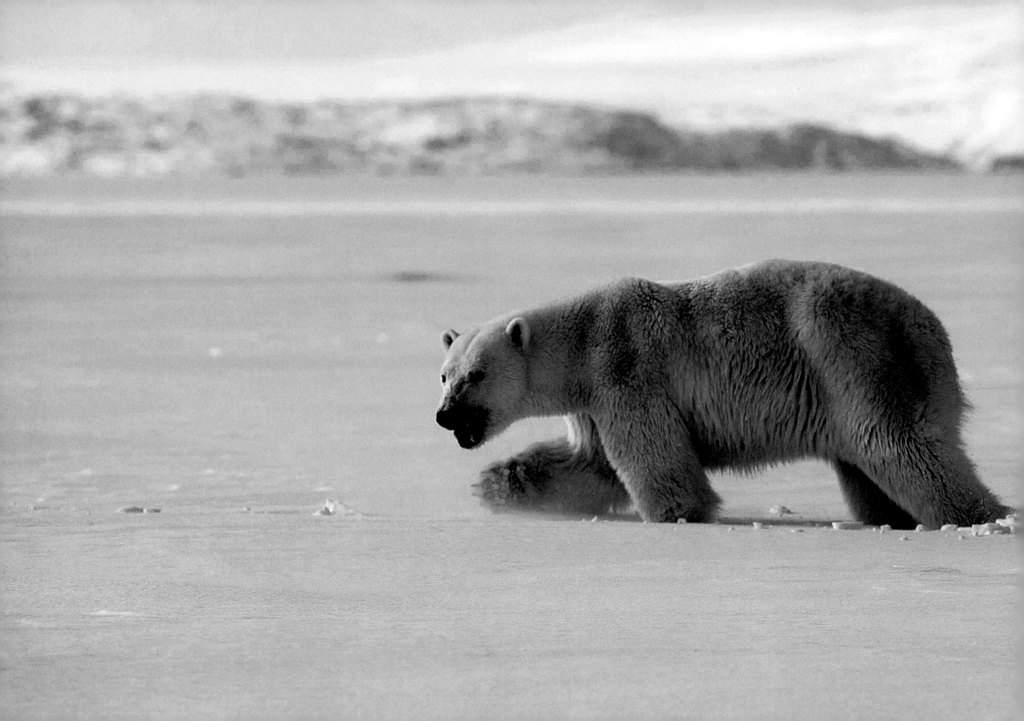

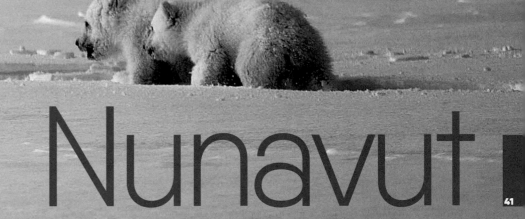

Nunavut

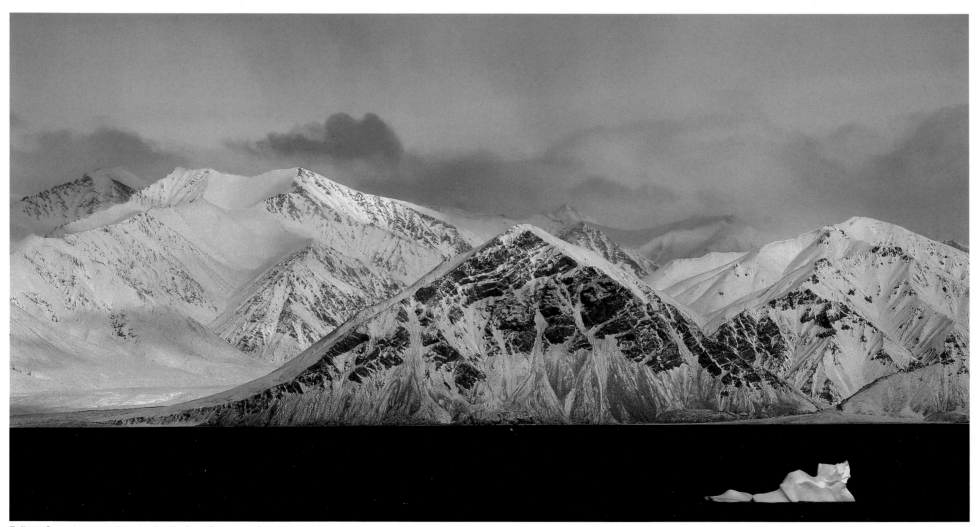

Eclipse Sound surrounding the Arctic Cordillera, near Pond Inlet, Nunavut

Nunavut is the largest of Canada's provinces and territories. The land was originally part of the Northwest Territories until 1999 when, as a result of the Land Claims Agreement, the Inuit were granted a territory comprising their traditional lands, including the right to participate in decisions regarding the land and its resources. The majority of Nunavut's population is Inuit. These Indigenous people are well adapted to living in arctic conditions, hunting and fishing on vast, frozen tundra. The traditional way of life is interspersed with modern technologies to utilize what is most practical; snowmobiles are prevalent, though dogsleds are still quite popular. The creative beauty of Inuit art, sewing, and sculpture is masterful. Traditional music includes the haunting sounds of throat-singing, a skill sometimes mixed with a modern beat.

Nunavut truly is "the great outdoors." Incredible vistas may appear lonely at first, but pause for a moment and the tranquility shines through. Locals and visitors alike respect the accessibility of trails according to the whim of nature. July and August are best for hiking but extra time must always be allotted. Rivers should be scouted, and polar bear safety tips considered. One good back-to-nature experience is the Akshayuk Pass in Auyuittuq National Park. View the twin peaks of Mount Asgard (Norse for "the realm of the gods") which were made popular in the opening sequence of the James Bond film *The Spy Who Loved Me*, featuring stuntman Rick Sylvester skiing off the mountain in a startling BASE jump, and floating to safety under a Union Jack parachute.

This territory is a big, bold destination. Nunavut, meaning "our land" in Inuktitut, the Inuit language, stretches from Cape Columbia to Stag Island and is loved for its raw energy and unspoiled scenery.

NUNAVUT

Our land, our strength

Joined confederation in 1999

Capital: Iqaluit

Flower: Purple saxifrage

Interesting Fact: Nunavut includes most of the Canadian Arctic Archipelago and is the northernmost region of Canada. It is also the country's newest, largest, and least populous territory.

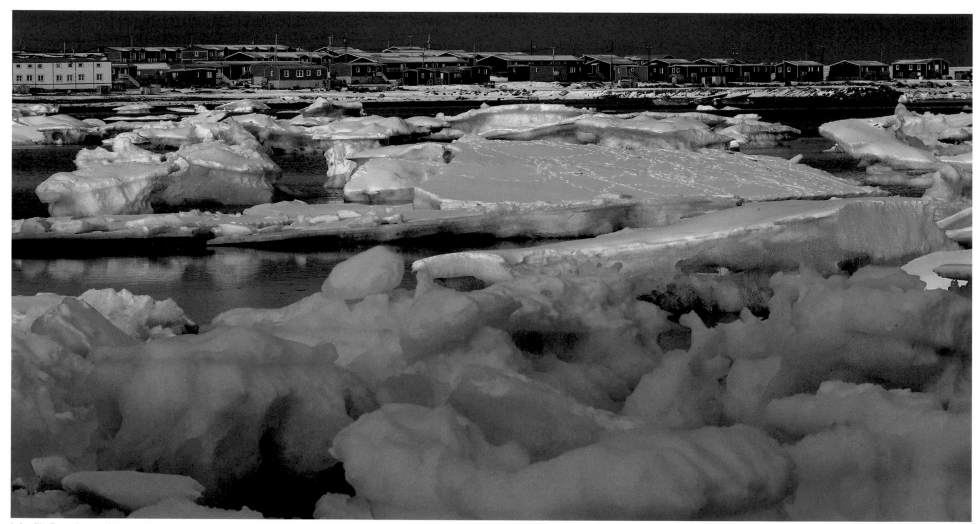

Igloolik, Foxe Basin, Qikiqtaaluk Region, Nunavut

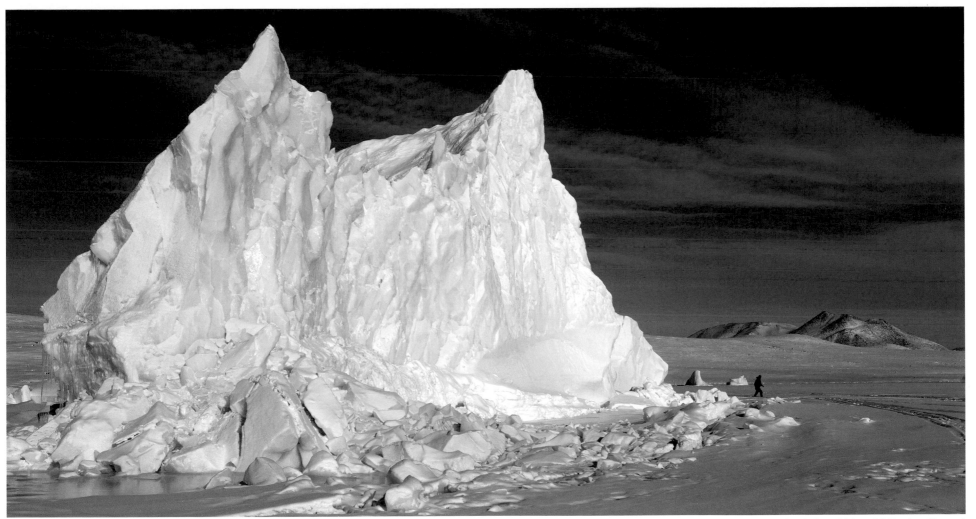

Arctic Bay, Qikiqtaaluk Region, Nunavut

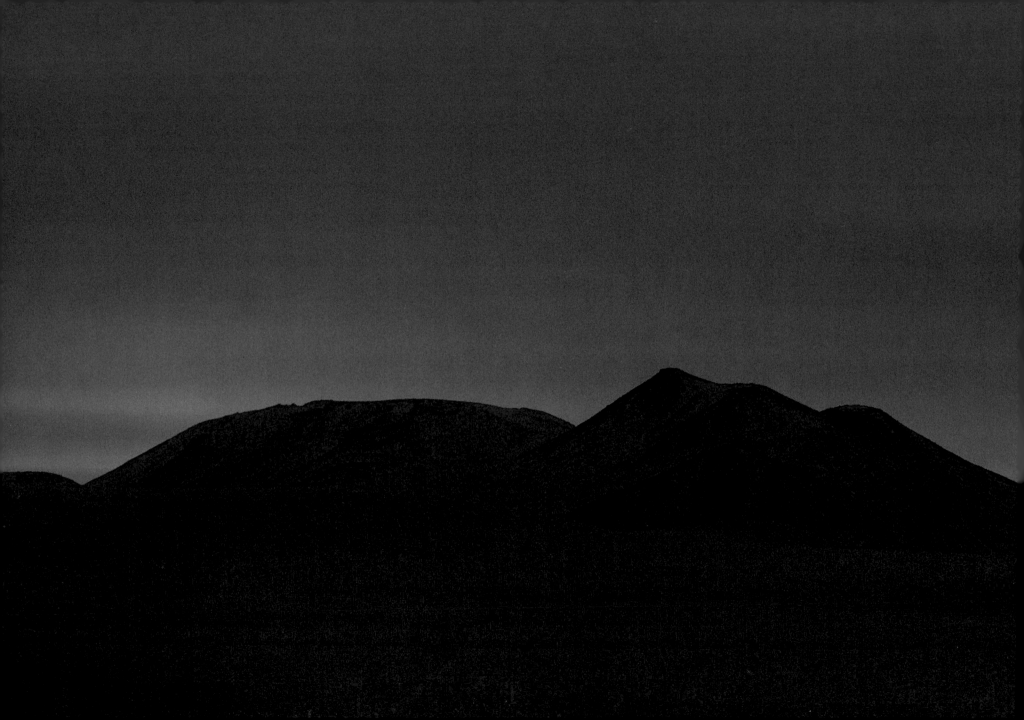

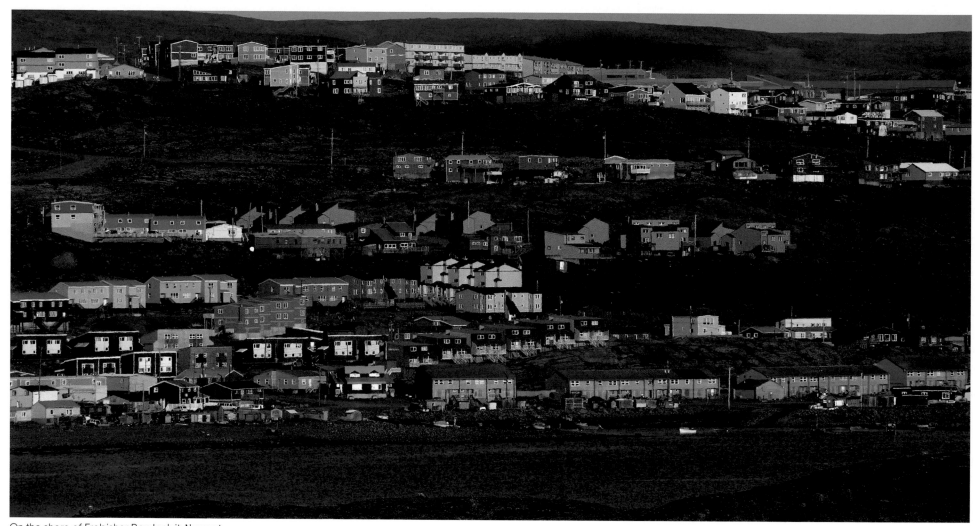

On the shore of Frobisher Bay, Iqaluit, Nunavut

Akshayuk Pass in the Penny Highlands. Auyuittuq National Park, Baffin Island, Nunavut

PREVIOUS SPREAD: Cumberland Peninsula, Qikiqtaaluk Region, Nunavut

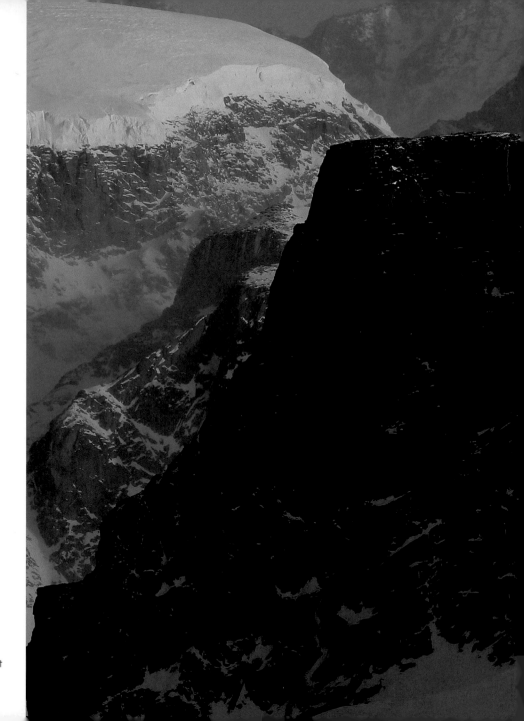

To survive the Canadian winter, one needs
a body of brass, eyes of glass, and
blood made of brandy.

LOUIS ARMAND, BARON DE LAHONTAN,
SOLDIER, EXPLORER, WRITER

The twin peaks of Mount Asgard, Baffin Mountain Range, Auyuittuq National Park, Nunavut

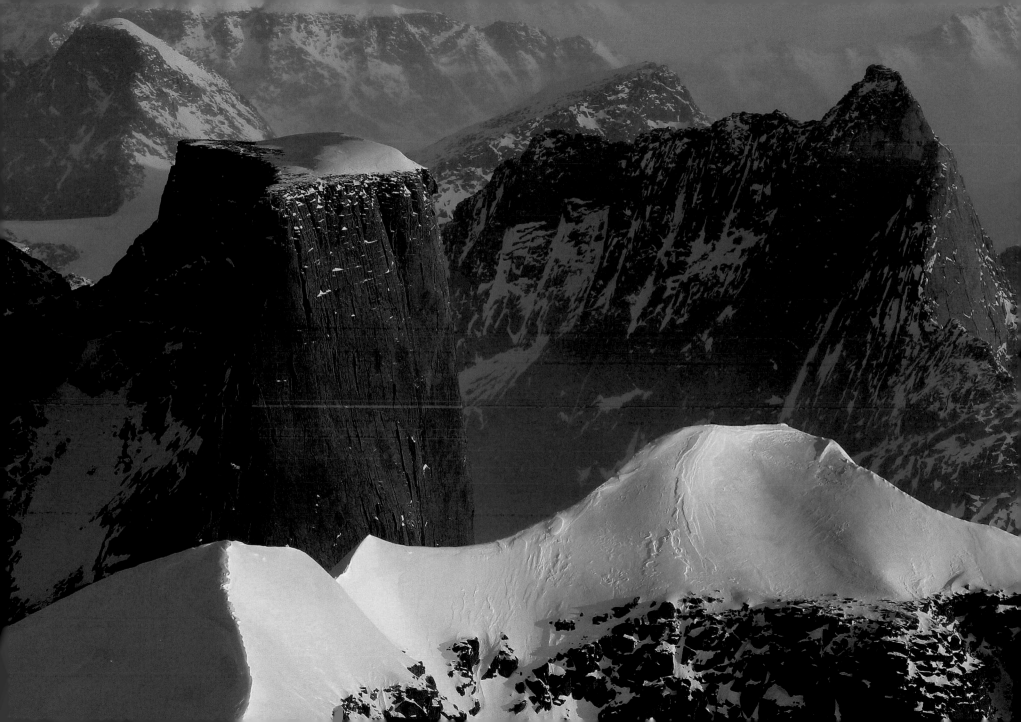

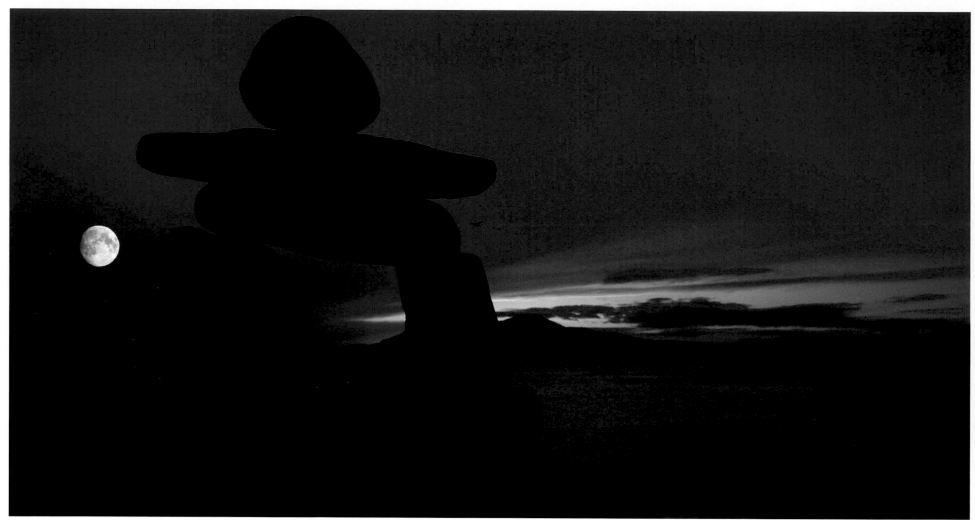

Near Cape Dorset, Nunavut

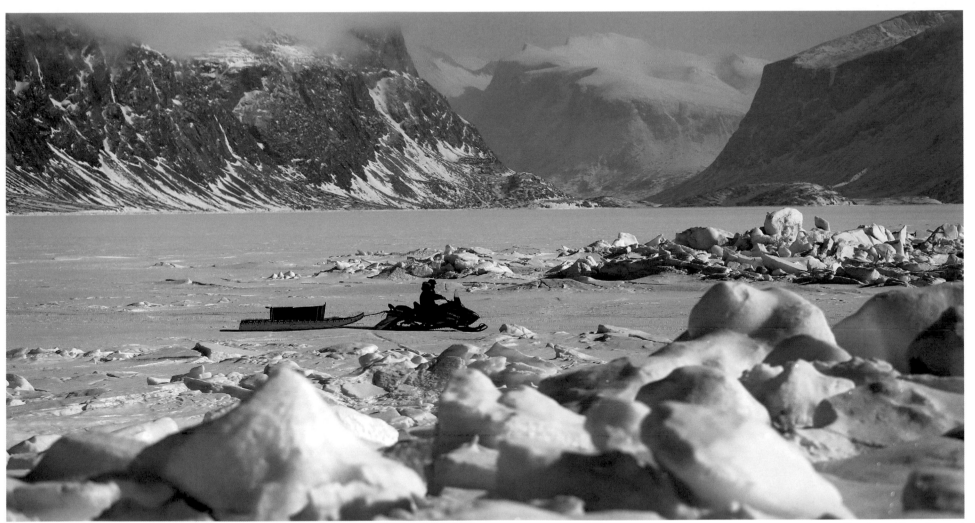

Near Pangnirtung, Nunavut

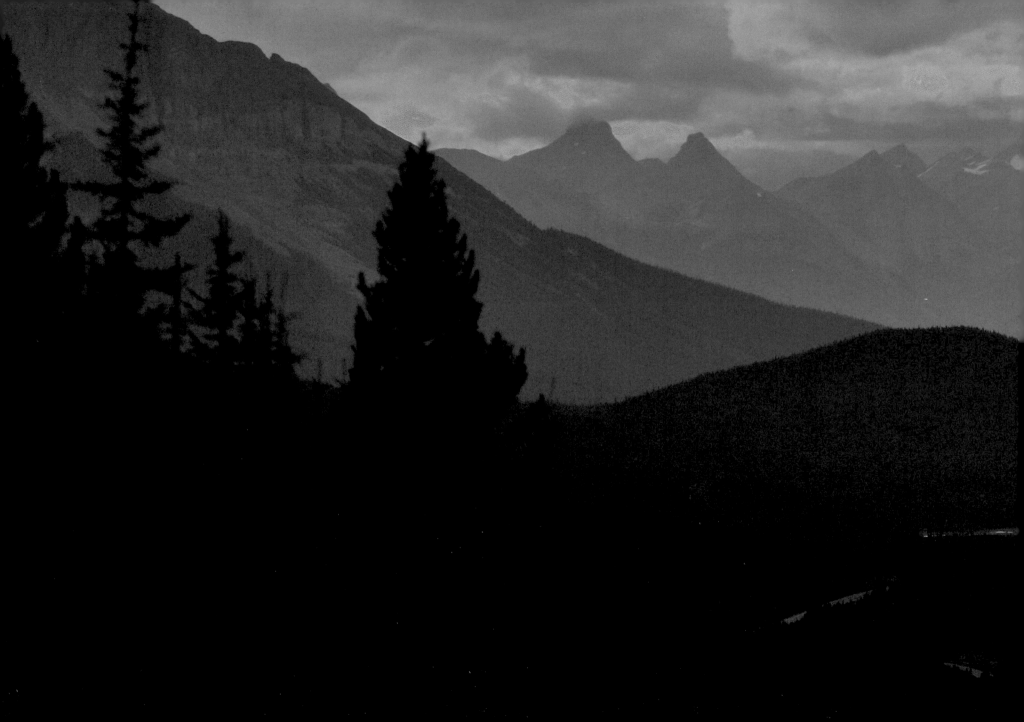

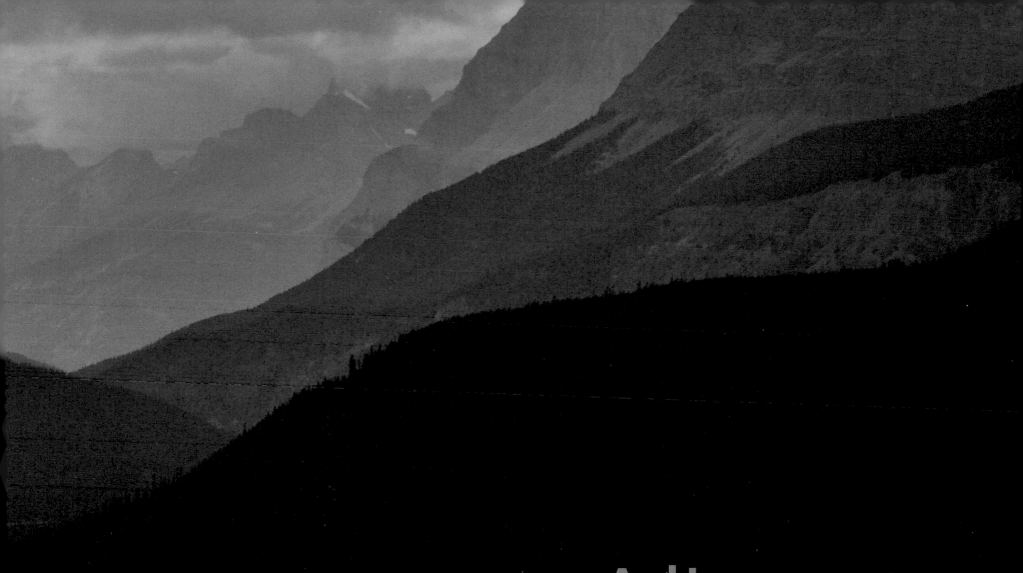

Alberta

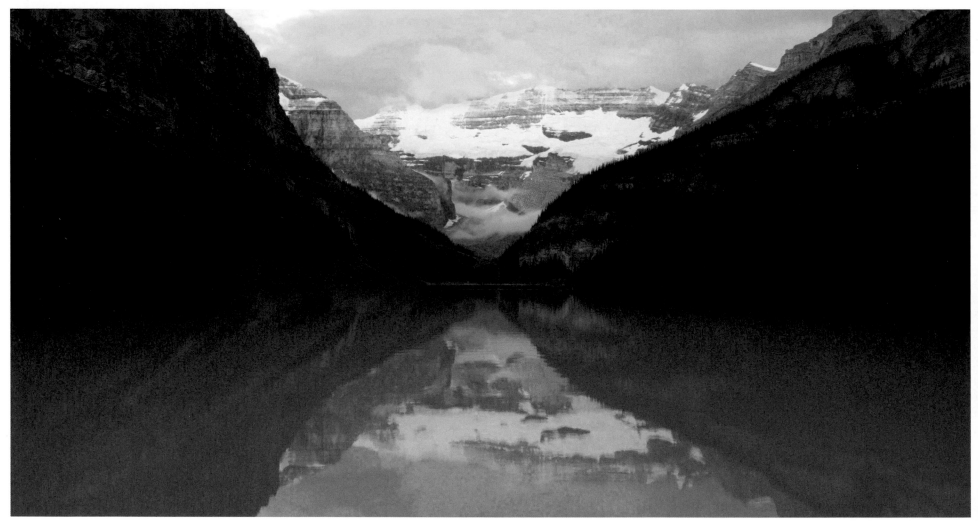

Lake Louise, Banff National Park, Alberta

Alberta and adventure must be synonymous in the Canadian dictionary. There is majesty everywhere you look, and in the spectacular Rocky Mountains it is most evident. Banff and Jasper, two incredible national parks, are the pinnacle of places to explore here. Jagged peaks quietly rise south of the Athabasca oil sands, boreal forests, and muskegs. Picturesque trails and white water beckon outdoor enthusiasts of every level. Famous places like the turquoise Lake Louise, the dramatic Icefields Parkway, the enormous Athabasca Glacier, the moon-like landscape of Drumheller, and the history of Head-Smashed-In Buffalo Jump are waiting to be discovered.

The First Nation people were here long before European settlers. Although settlements would not be established until the mid-1700s, In the late 1600s Henry Kelsey, an English fur trader, recorded accounts of tribal politics. The migration of pioneers took hold after 1885 at the end of the North-West Rebellion (when Louis Riel was taken prisoner). Towns along railways developed quickly and farming began.

This diverse province is also a great place to kick up your heels. K-Days (formerly known as Klondike Days) in Edmonton flows with the excitement of concerts, carnival rides, and a powwow with the Alexis Nakota Sioux Nation. The Edmonton Folk Music Festival and Edmonton International Fringe Theatre Festival attract tens of thousands to take in the sights and sounds. Not to be outdone, the annual Calgary Stampede brings over a million visitors for ten days of rodeos, concerts and parades, chuckwagon racing, powwows, and barbecues.

Where else can both cowboys and kayakers find their bliss? With so many fascinating places to see, every Canadian should make Alberta a destination.

ALBERTA

Strong and free

Joined confederation in 1905

Capital: Edmonton

Flower: Wild rose

Interesting Fact: The Royal Tyrrell Museum in Alberta's Badlands is home to the world's largest collection of full-scale dinosaur skeletons.

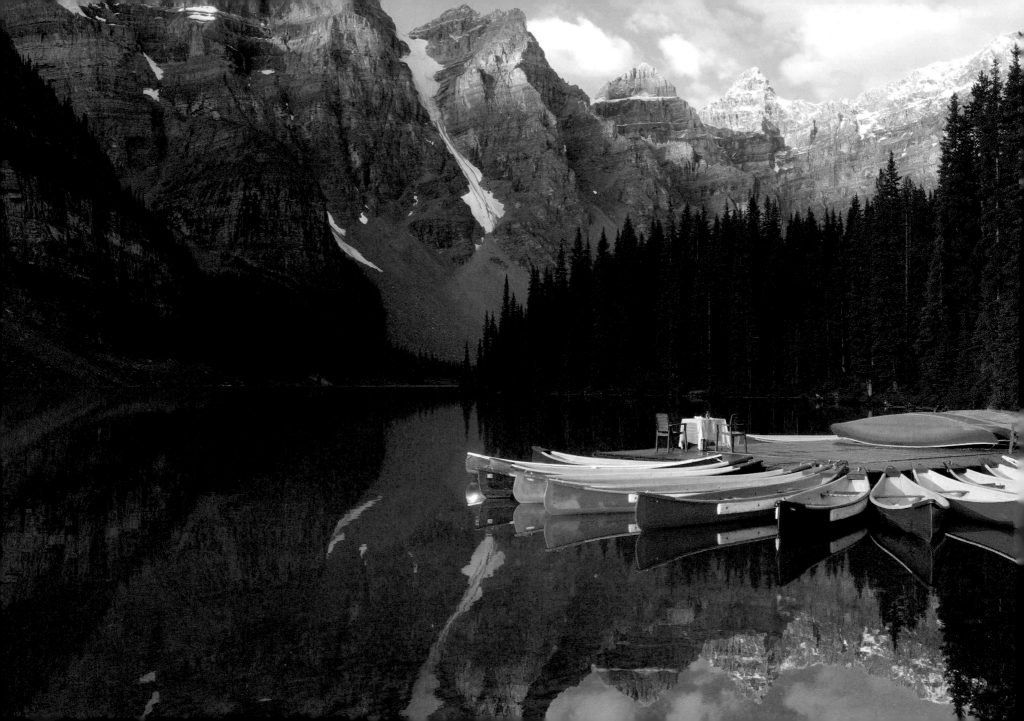

I am a Canadian, free to speak without fear, free to worship in my own way, free to stand for what I think right, free to oppose what I believe wrong, or free to choose those who shall govern my country. This heritage of freedom I pledge to uphold for myself and all mankind.

JOHN G. DIEFENBAKER, FORMER PRIME MINISTER OF CANADA

Moraine Lake and the Valley of the Ten Peaks, Banff National Park, Alberta

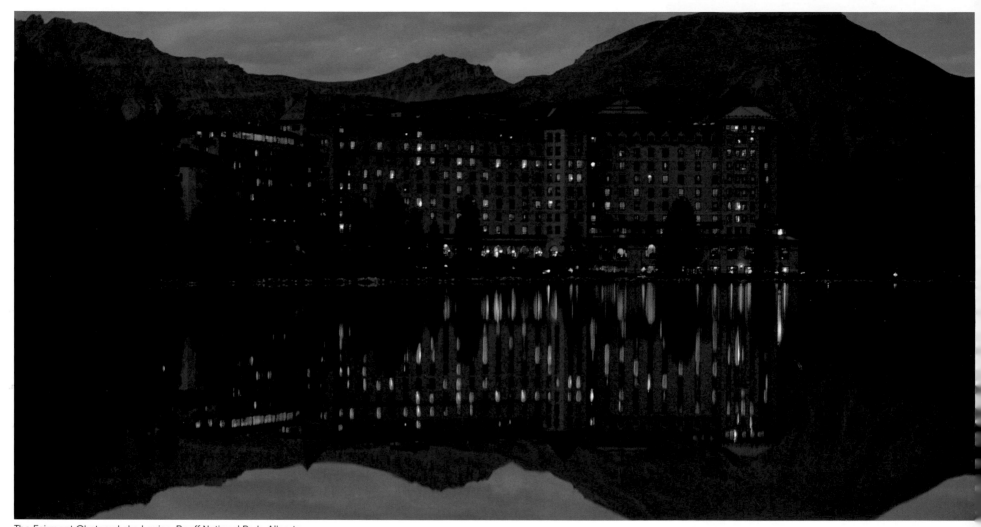

The Fairmont Chateau Lake Louise, Banff National Park, Alberta

The Devils Thumb, Banff National Park, Alberta

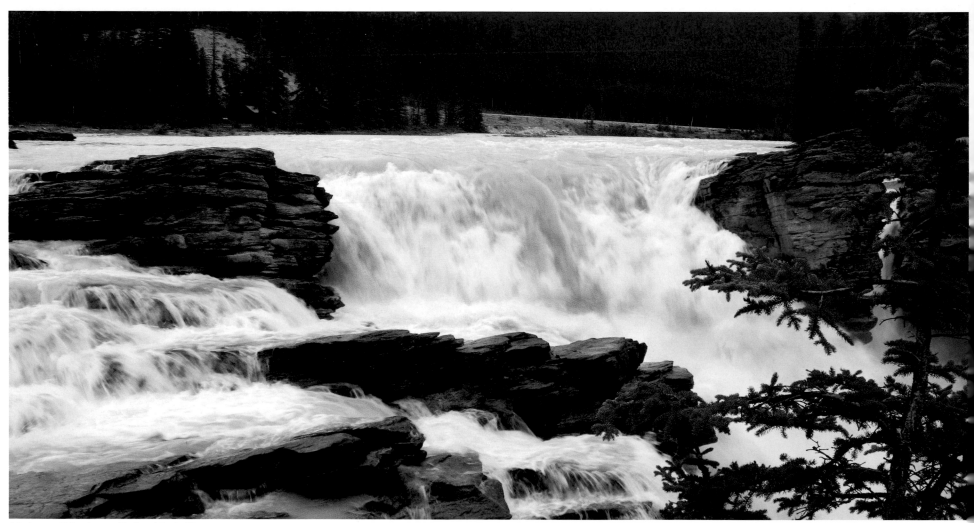

Athabasca Falls, Jasper National Park, Alberta

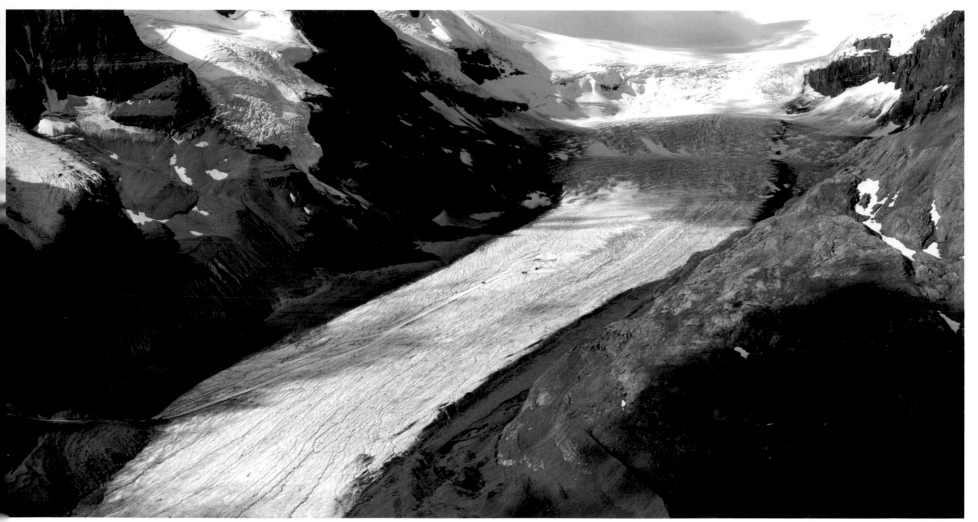

Athabasca Glacier, Columbia Icefield, Alberta

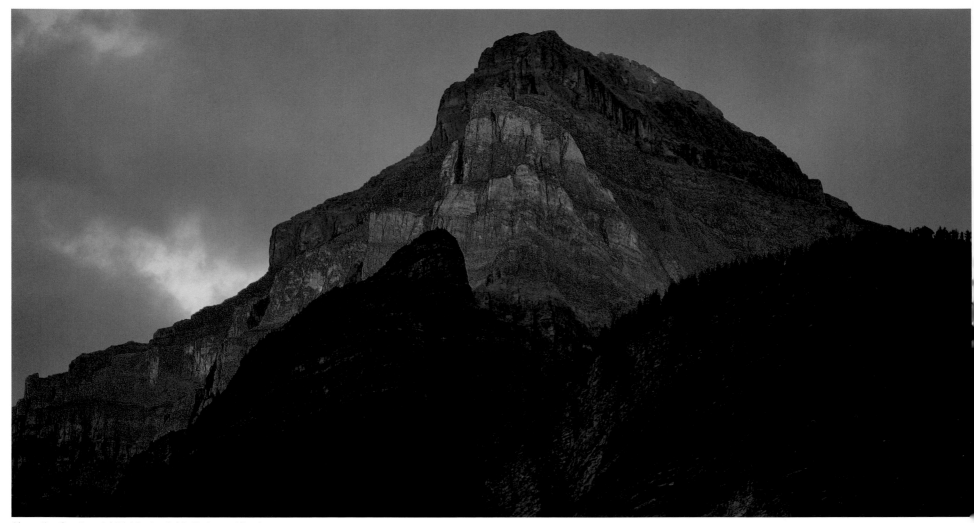

Along the Continental Divide, Icefields Parkway, Alberta

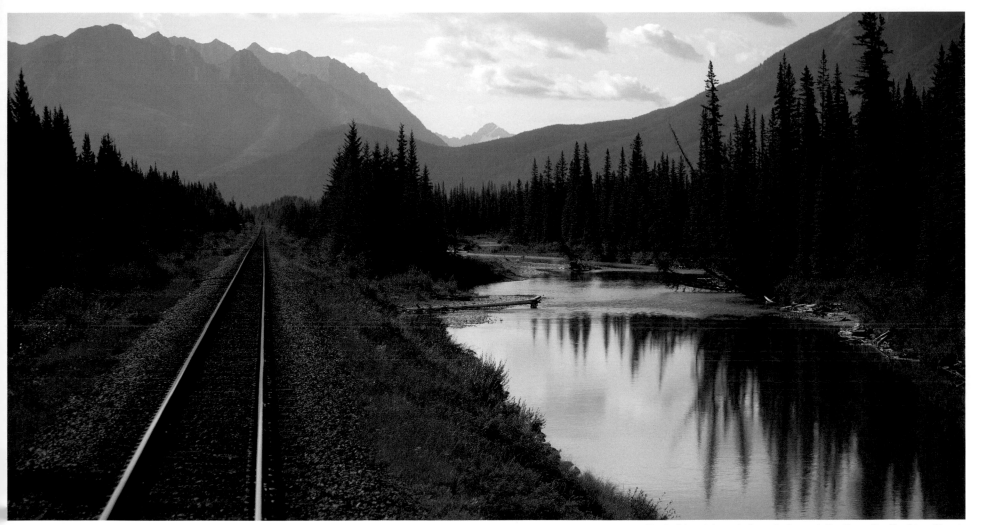

Rocky Mountaineer train route through the Canadian Rockies, Alberta

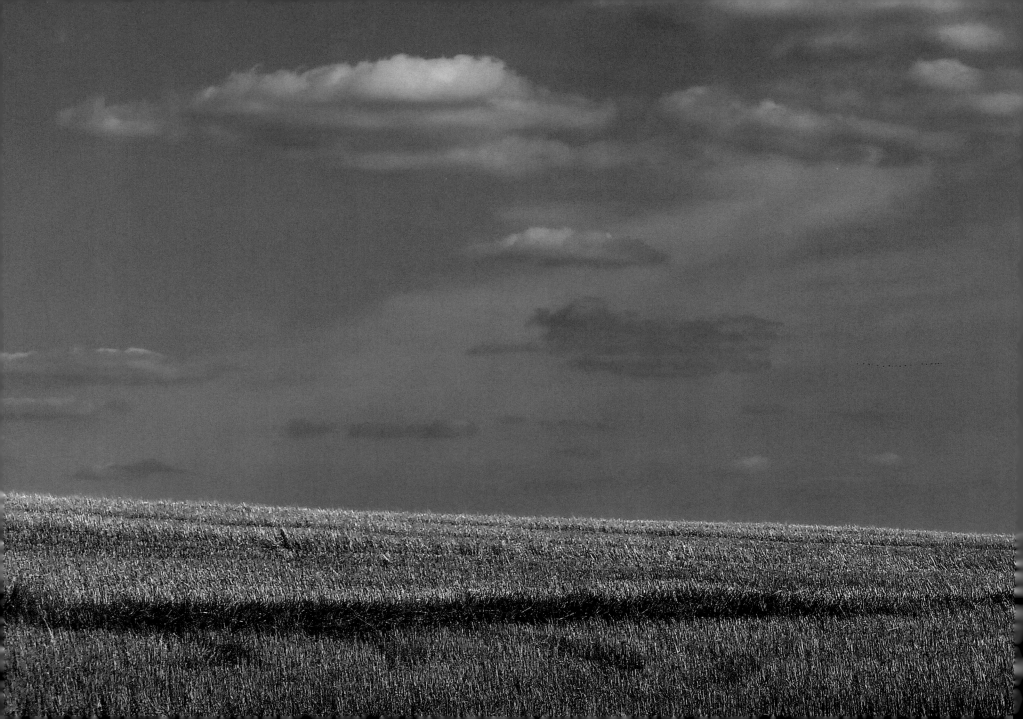

Saskatchewan

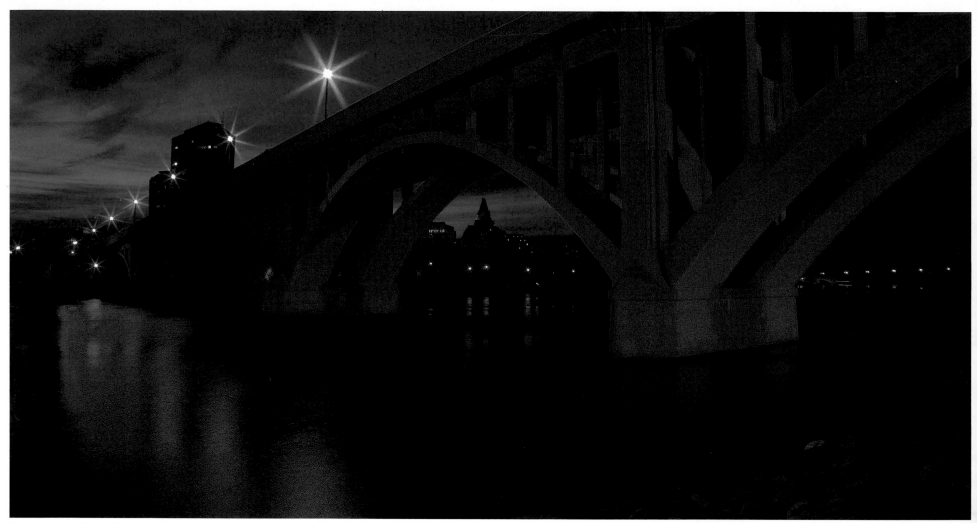

The Broadway Bridge, Saskatoon, Saskatchewan

A province of colours, Saskatchewan's landscape is surprisingly diverse and those merely travelling through risk missing its rich tapestry. Verdant green boreal forest and sparkling blue lakes trickle down to golden wheat fields. Vibrant red serge of the Royal Canadian Mounted Police (RCMP) uniform offsets the Saskatchewan Roughriders' "Ridernation" green. Rolling emerald hills and grassland support shaggy brown bison and dip down to the reds, yellows, and browns of the badlands and sand dunes.

The middle of three Prairie provinces, Saskatchewan sits under the Northwest Territories. Its shared northern border enjoys a similar weave of glassy lakes and gushing rivers, where diversions become one of the best parts of the journey.

The southern portion accommodates most of the population in spirited cities housing important museums and galleries, as well as great shopping and world-class cuisine. Unexpected sites showcase thriving art communities and traditional archictecture. During the last few centuries, settlements were positioned around the best route to get crops to market. Horse and wagon, trucks and trains were all tools for efficient transportation. For most of the 1900s, grain elevators were farmer-owned cooperatives. Dotting the otherwise flat landscape, these "prairie sentinels" are now a part of history and a sentimental subject for artists.

Darker plots come to light in the industrial steam tunnels under Moose Jaw, where Chinese immigrants hid from racism and were used as cheap labour in underground laundries and gunny-sack factories, and passageways were used for bootlegging during Prohibition in the United States. Significant stories are also found at the Royal Canadian Mounted Police Heritage Museum. It is easy to picture infamous outlaws like Sam Kelly and the Sundance Kid who once hid out from the North West Mounted Police in Saskatchewan's Big Muddy badlands.

The saltwater Little Manitou Lake, where it's almost impossible to sink and "even a goat can float," is legendary. Gaze across rolling hills in Grasslands National Park and discover the ecosystems in Athabasca Sand Dunes Provincial Park and the Great Sandhills Ecological Reserve. There is so much to see, with eye-opening panoramas offering a whole new outlook – off Saskatchewan's beaten path.

SK
SASKATCHEWAN

Strength from Many Peoples

Joined confederation in 1905

Capital: Regina

Flower: Western red lily

Interesting Fact: Saskatchewan boasts 100,000 lakes with myriad beaches. However, the vastest expanse of sand is found at the Athabasca Sand Dunes Provincial Park and Great Sandhills Ecological Reserve; each contains surprising large, active sand dunes.

PREVIOUS SPREAD: Canola field near Wakaw, Saskatchewan

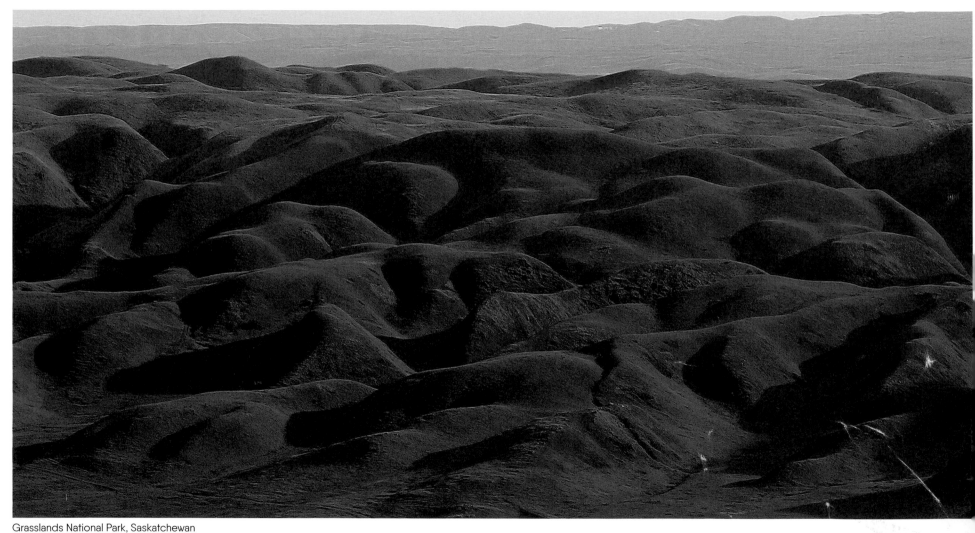

Grasslands National Park, Saskatchewan

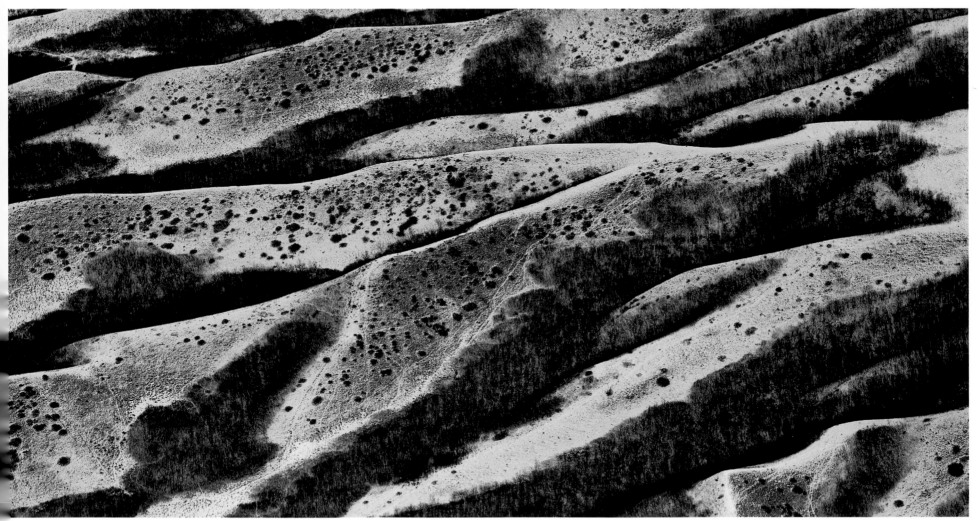

Qu'Appelle Valley, Saskatchewan

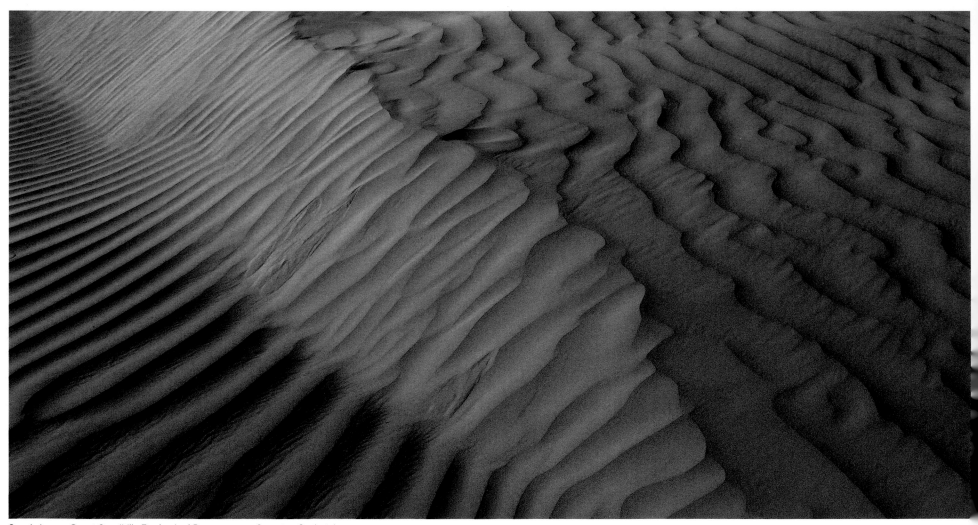

Sand dunes, Great Sandhills Ecological Reserve near Sceptre, Saskatchewan

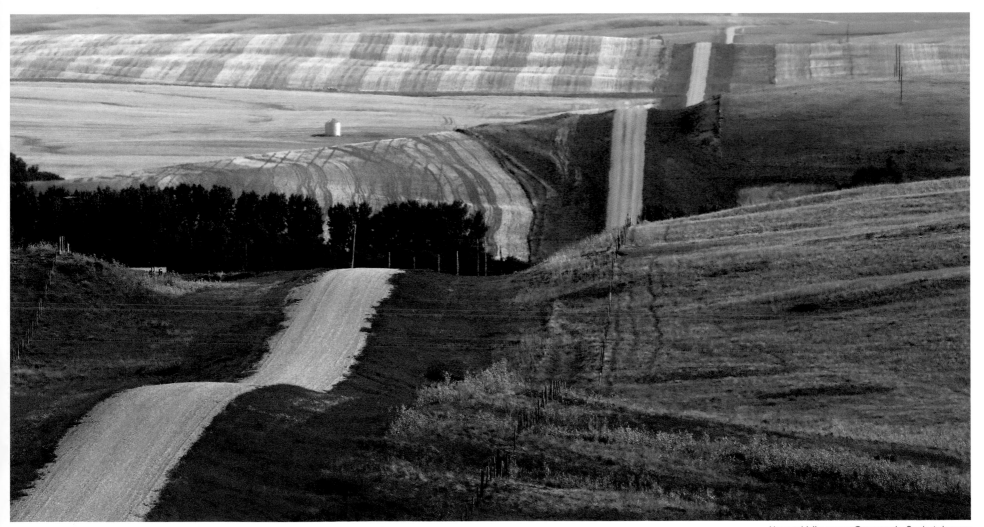

Happy Valley near Coronach, Saskatchewan

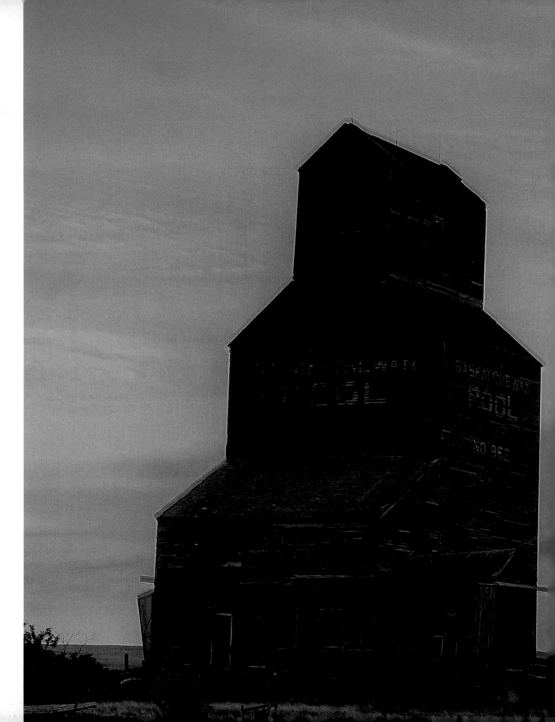

"*It is said, that when God made this world he made many different things, that is why the newcomers and First Nations people must help each other and work together.*"

—Louie Dih ttheda, Dene Elder,
Black Lake First Nation

Wheat Pool grain elevator, Bents, Saskatchewan

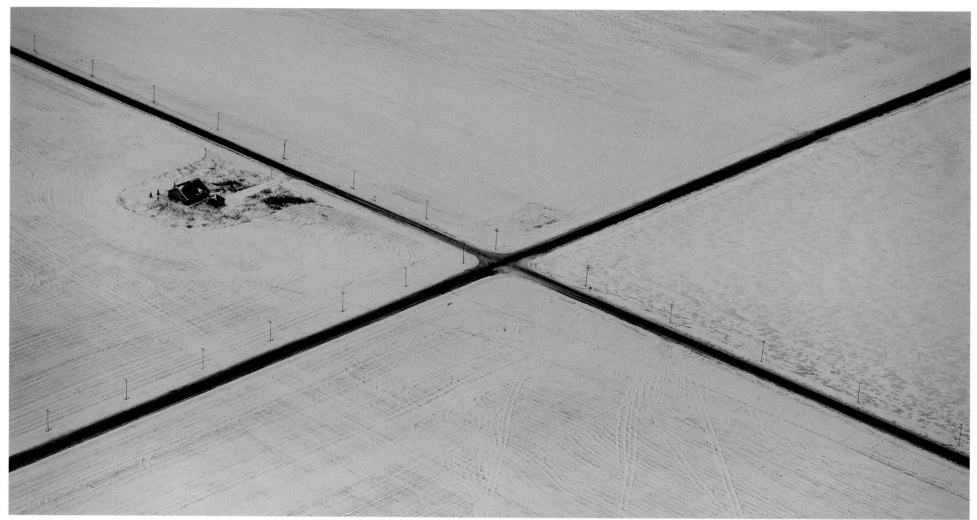

Winter fields, northeast of Regina, Saskatchewan

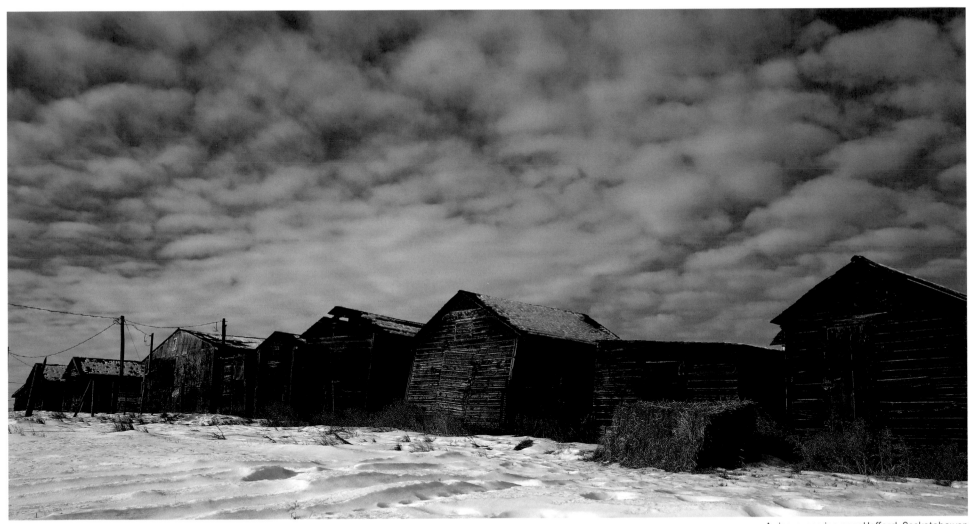

Aging granaries near Hafford, Saskatchewan

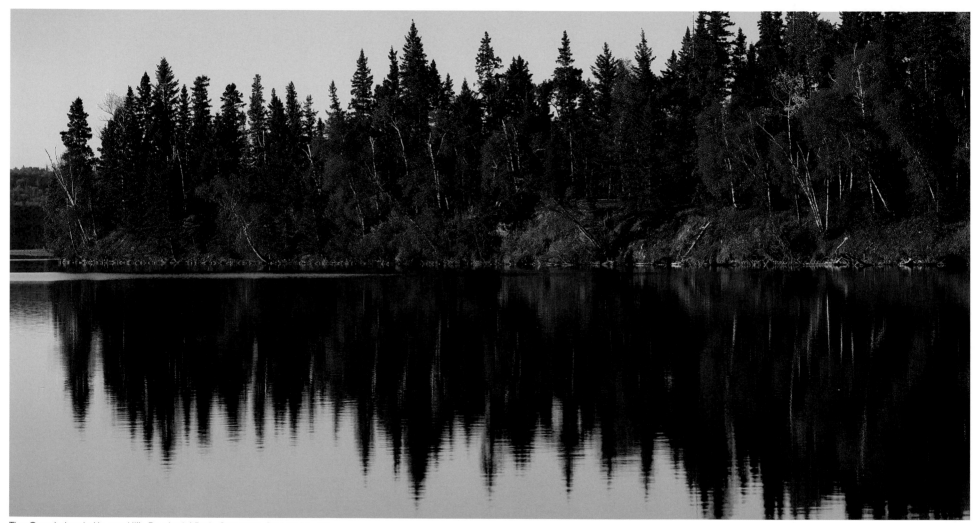

The Gem Lakes in Narrow Hills Provincial Park, Smeaton, Saskatchewan

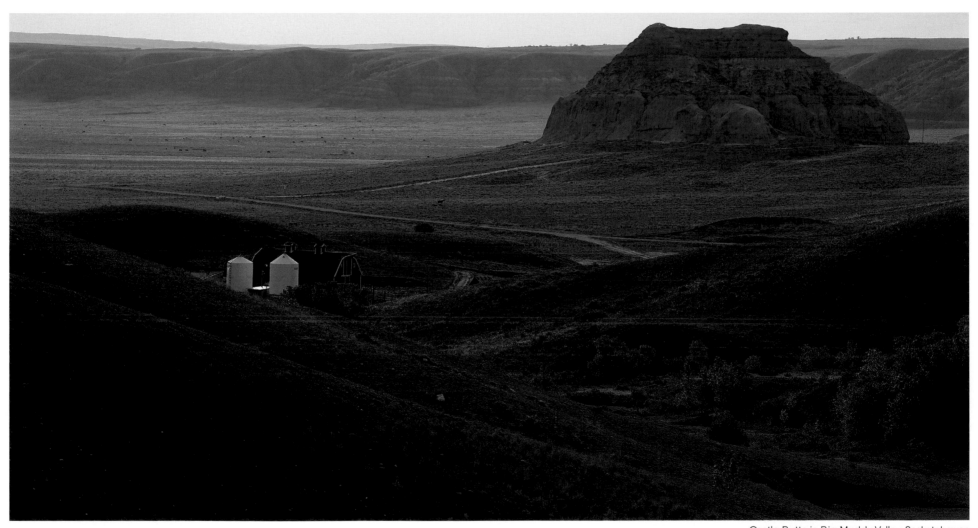

Castle Butte in Big Muddy Valley, Saskatchewan

Manitoba

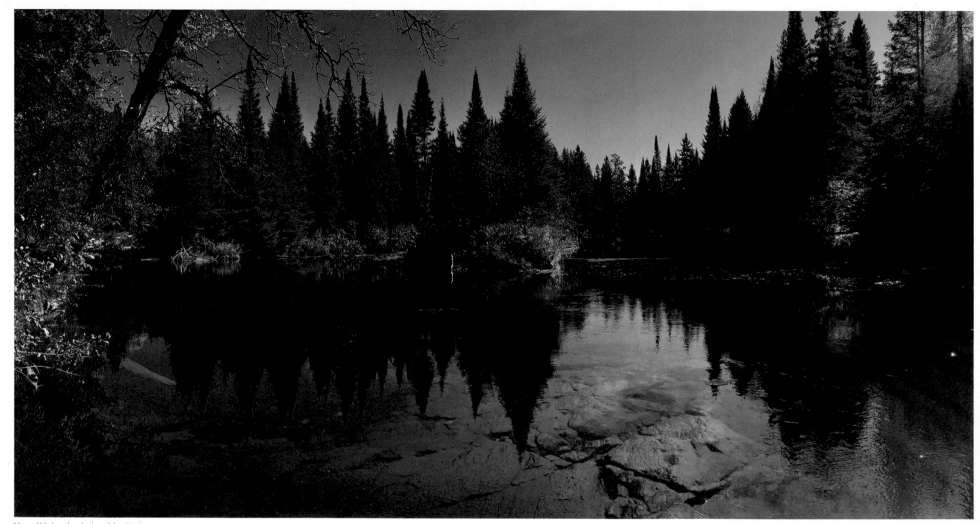

Near Wekusko Lake, Manitoba

Beautiful Manitoba nurtures a wealth of Canada's best-kept secrets. Top-ranked by Environment Canada for the country's clearest skies, Manitoba is a perfect place to watch the Aurora Borealis. Interestingly, it is also Canada's sunniest province. Extremes are a source for boasting: low temperatures have rivaled those on Mars, and some of the largest fish on the continent have been pulled from Manitoba's more than 100,000 lakes. Powerful, in-your-face nature can be found by the intrepid in Churchill, known as the "Polar Bear Capital of the World," close to Wapusk National Park, one of the largest denning areas on earth. Beluga whales also glide in, visiting from nearby Hudson Bay.

Originally Manitoba was known as the "postage stamp province" as its borders before 1881 were one-eighteenth of its current size. True to its Prairie province geography, agriculture is prevalent, but detours can turn up unexpected charms for travellers and adventurers. From the subarctic sixtieth parallel to the humid continental climate of the forty-ninth parallel, there are panoramas and experiences galore. The excitement of Manitoba's cities should not be overlooked. The capital city, Winnipeg, is full of things to do and see, from the renowned Royal Winnipeg Ballet to Canada's Museum for Human Rights. Natural beauty is captured in every season and with limitless ideas for visitors, it's a great place to play. Hike, bike, canoe, camp, rock climb, or raft under larger-than-life skies. Ski, snowmobile, dog sled, or snow-kite on frozen lakes. And take in the extraordinary scenery.

Manitoba's rugged beauty and the warmth of its people make this an unforgettable part of Canada, and one that should not be missed.

MANITOBA

Glorious and free

Joined confederation in 1870

Capital: Winnipeg

Flower: Prairie crocus

Interesting Fact: As the weather turns from winter to spring, thousands of snakes emerge from Manitoba's subterranean Narcisse Snake Dens to find area marshes in which to summer.

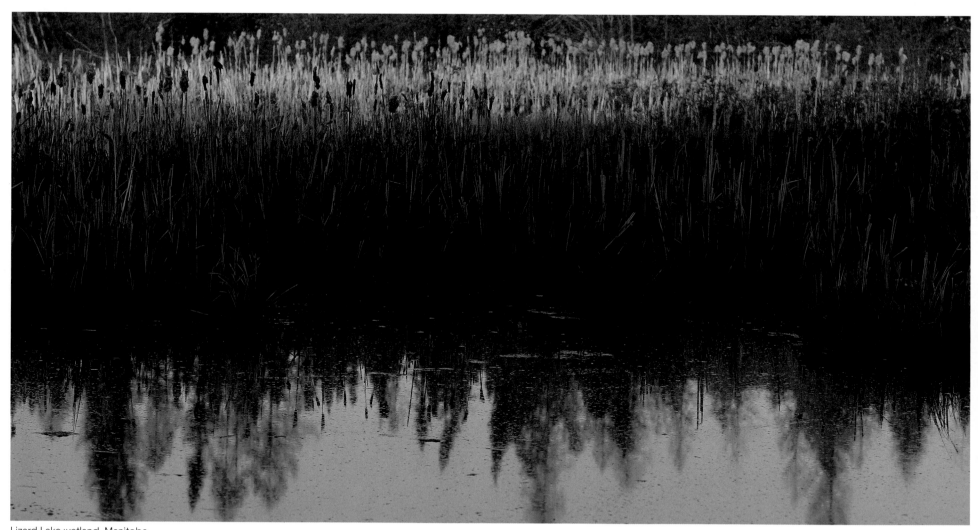

Lizard Lake wetland, Manitoba

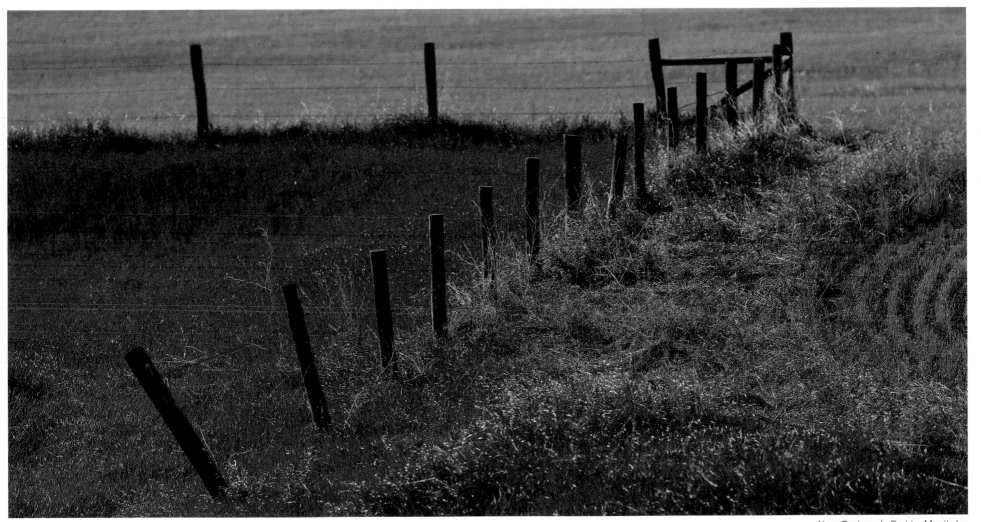

Near Portage la Prairie, Manitoba

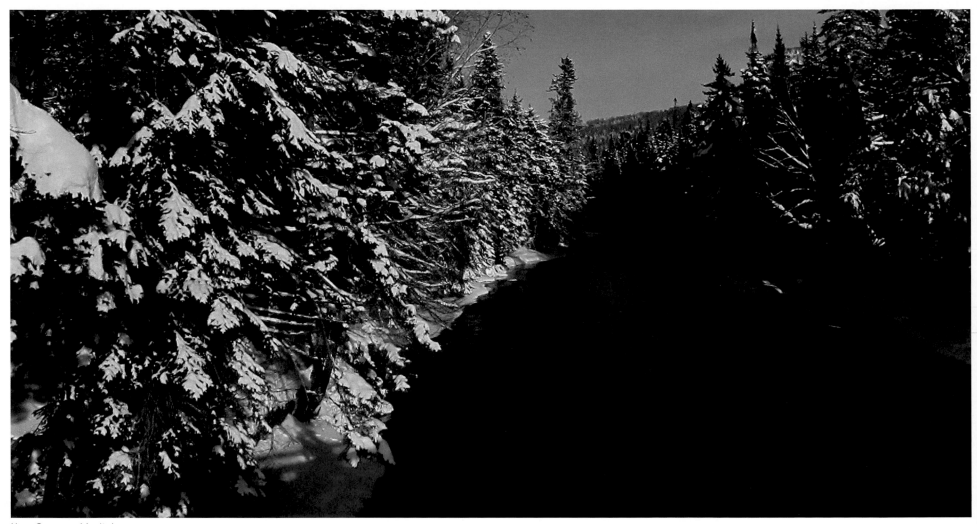

Near Comeau, Manitoba

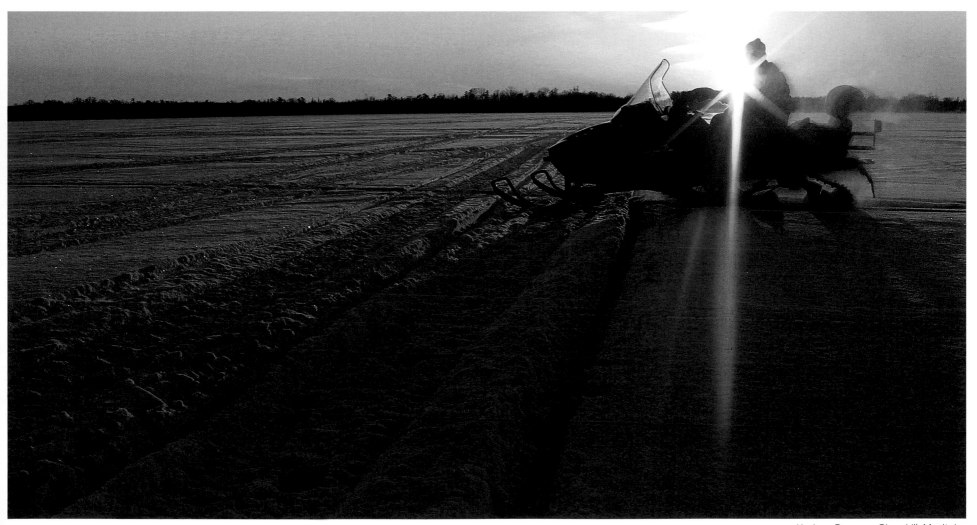

Hudson Bay near Churchill, Manitoba

PREVIOUS SPREAD: Farming near Brandon, Manitoba

Hudson Bay, Churchill, Manitoba

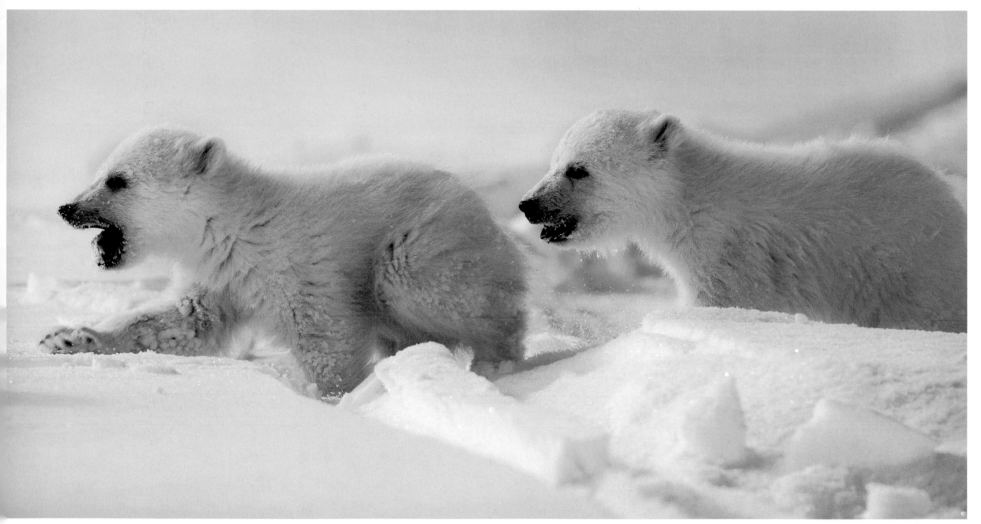

Churchill, Manitoba

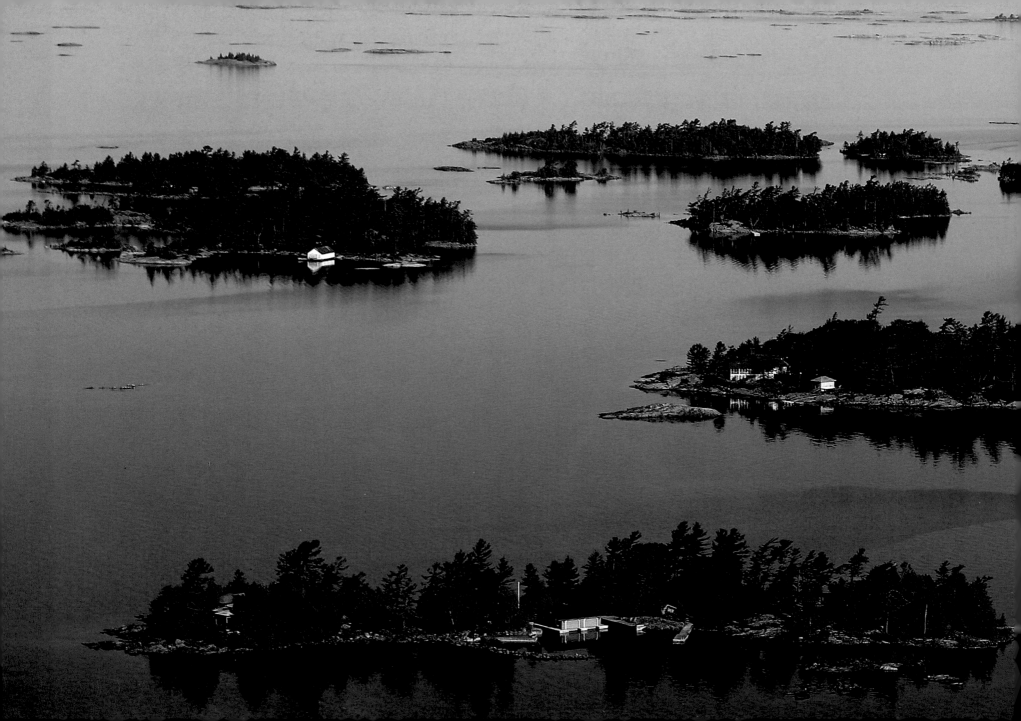

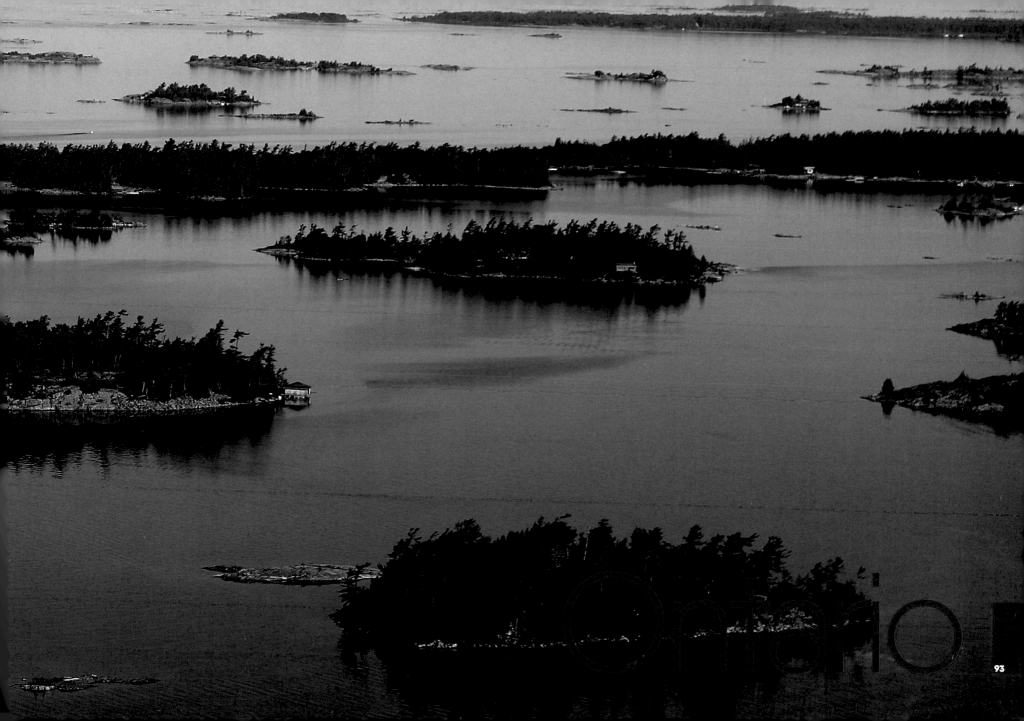

Autumn in Algonquin Park, Whitney, Ontario

Geographically, the province of Ontario is sometimes divided conceptually into north and south where the land pinches together at Lake Nipissing. The northern portion constitutes about 87 percent of the provincial area with about 6 percent of the population. The town of North Bay has even built a "Gateway of the North." Some areas are accessible only by paddling, hiking, or boarding a train. Famous landscapes captured by the iconic Group of Seven painters reward explorers with jaw-dropping scenery. Road trips are marked with friendly towns, each with a unique story.

The southern portion of Ontario is home to nearly 35 percent of Canada's total population. It is well known for tourism on many levels. Point Pelee National Park boasts the country's southernmost point of land, on Middle Island, almost parallel with northern California. The beautiful natural attraction of Niagara Falls attracts millions of visitors each year. Hamilton, known as the world's "waterfall capital," is a great place to join up with the

885-kilometre Bruce Trail or to find a path along the Niagara Escarpment. Beaches along the Great Lakes and parks on the Bruce Peninsula are sought-after refuges. The Thousand Islands region is a deserving destination with over 1,800 islands dotting the St. Lawrence River, unique in beauty, history, and culture.

Endless entertainment is available through the province's multitude of festivals and sporting events. Visitors can enjoy outstanding museums, art galleries, and wine tours. Toronto, the provincial capital, is the largest city in Canada and is home to the acclaimed CN Tower, one of the Seven Wonders of the Modern World. Canada's capital, Ottawa, is home to Parliament Hill, site of our federal government, which is close to the busy Rideau Canal and several notable museums.

Vast landscapes open up as travellers explore, and cities with energizing activities and thrilling nightlife all make up Ontario: yours to discover.

ONTARIO

Loyal she began, loyal she remains

One of the founding members of confederation in 1867

Capital: Toronto

Flower: White trillium

Interesting Fact: The Niagara River pours down 99 metres over the crest of Horseshoe Falls and continues along its route to drive almost 2 million kilowatts of electricity for Canada. It is Ontario Power Generation's largest and one of its most reliable hydroelectric facilities. It is Ontario Power Generation's largest hydroelectric facility, and one of its most reliable.

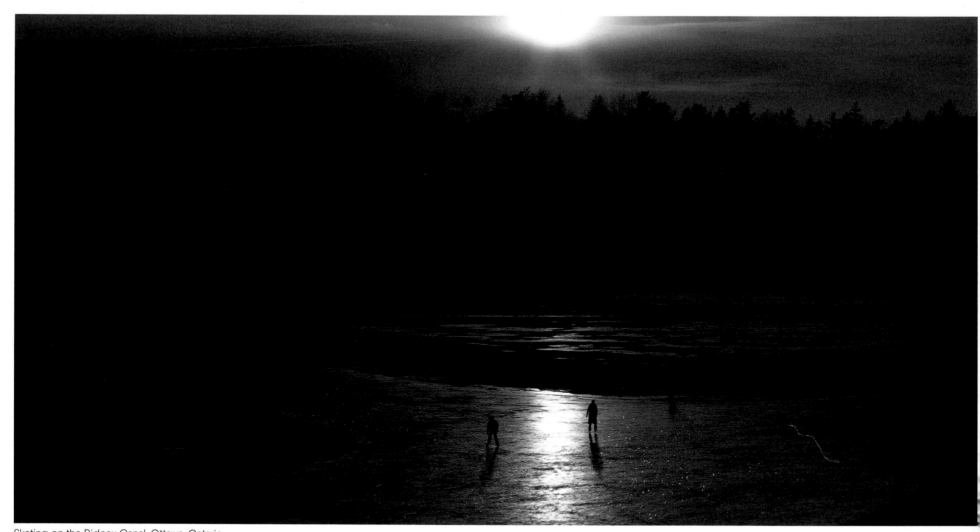

Skating on the Rideau Canal, Ottawa, Ontario

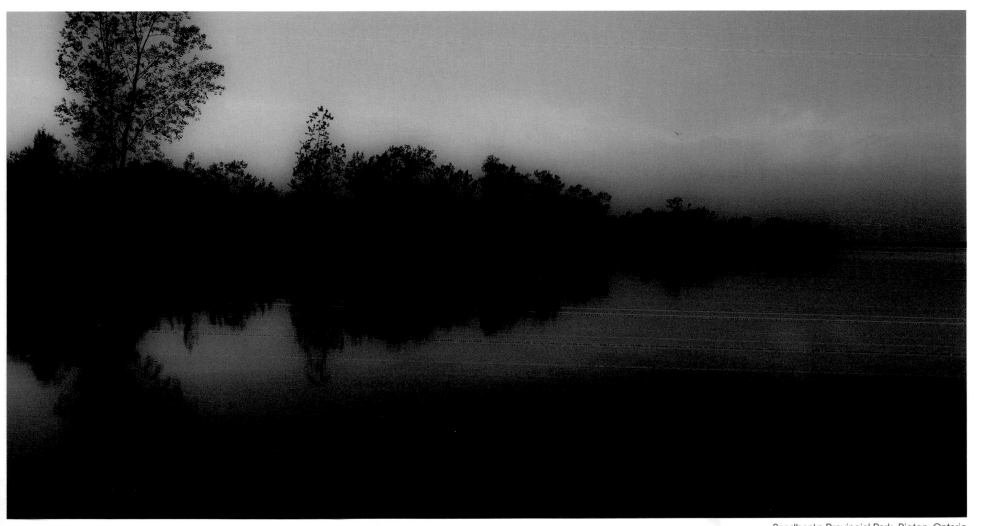

Sandbanks Provincial Park, Picton, Ontario

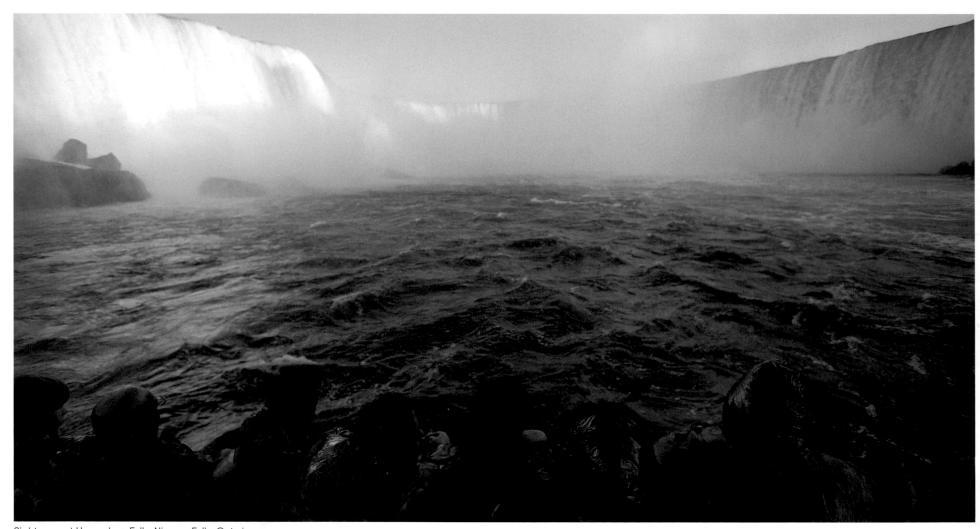

Sightseers at Horseshoe Falls, Niagara Falls, Ontario

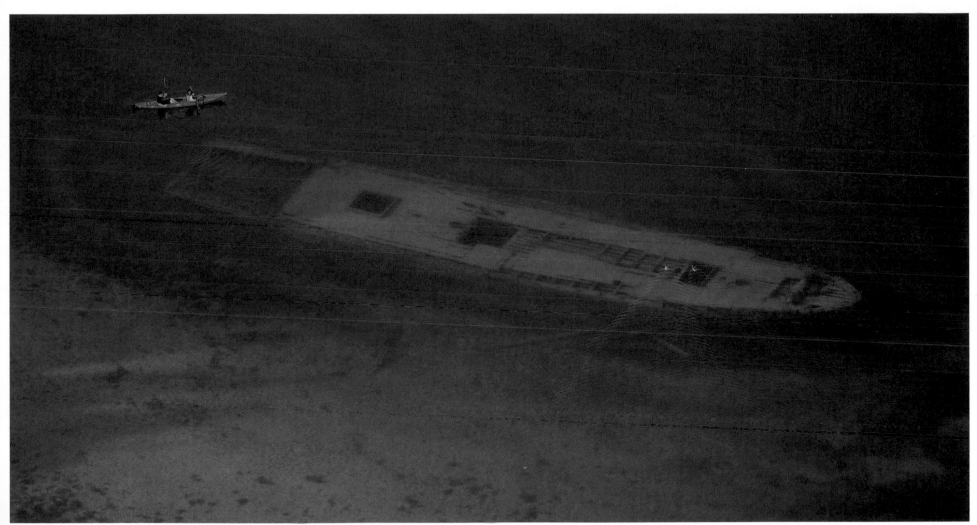

A shipwreck preserved in Fathom Five National Marine Park, Tobermory, Ontario

Georgian Bay near Parry Sound, Ontario

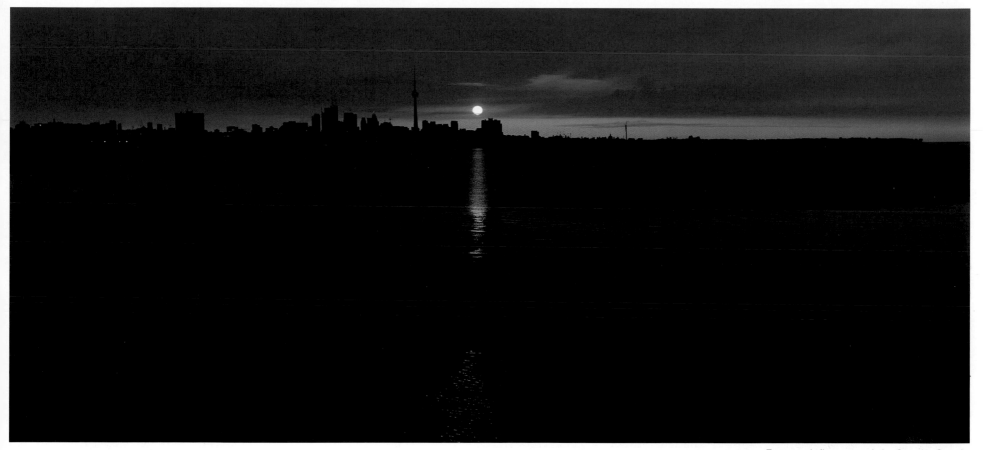

Toronto skyline across Lake Ontario, Ontario

I believe that never was a country better adapted to produce a great race of women than this Canada of ours, nor a race of women better adapted to make a great country.

EMILY MURPHY, FAMOUS FIVE SUFFRAGIST, REFORMER, AND WRITER

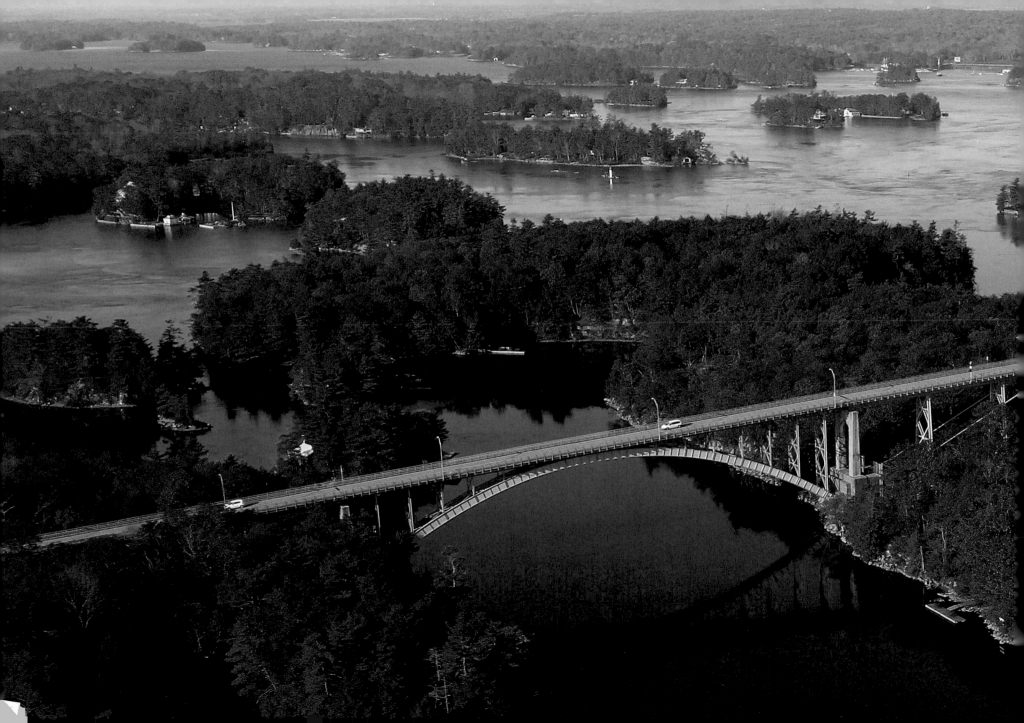

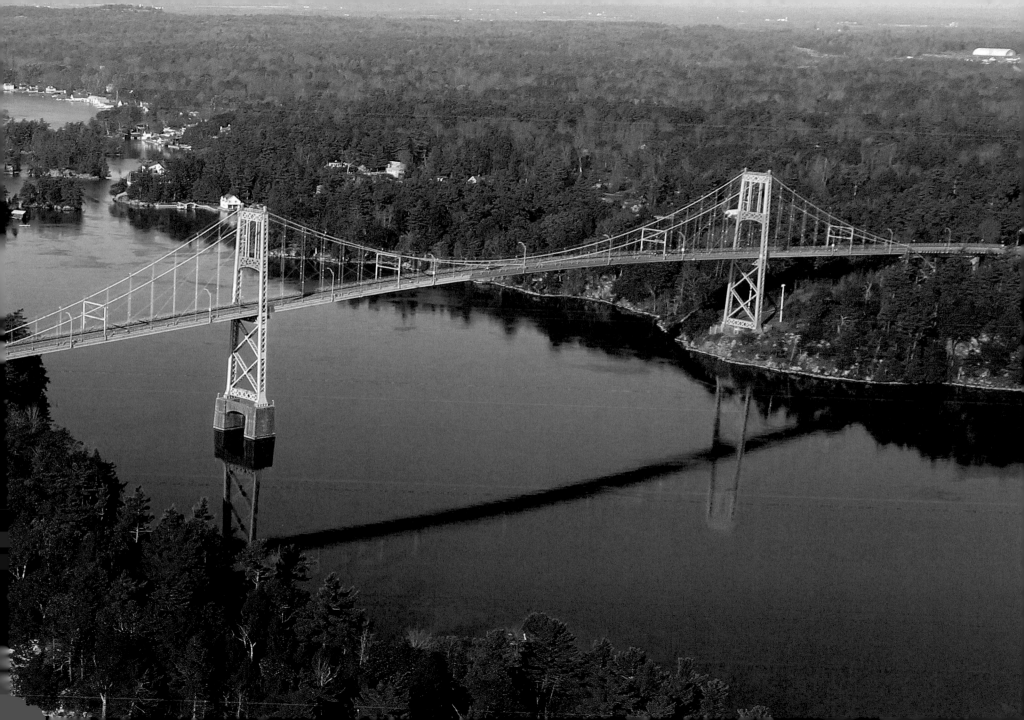

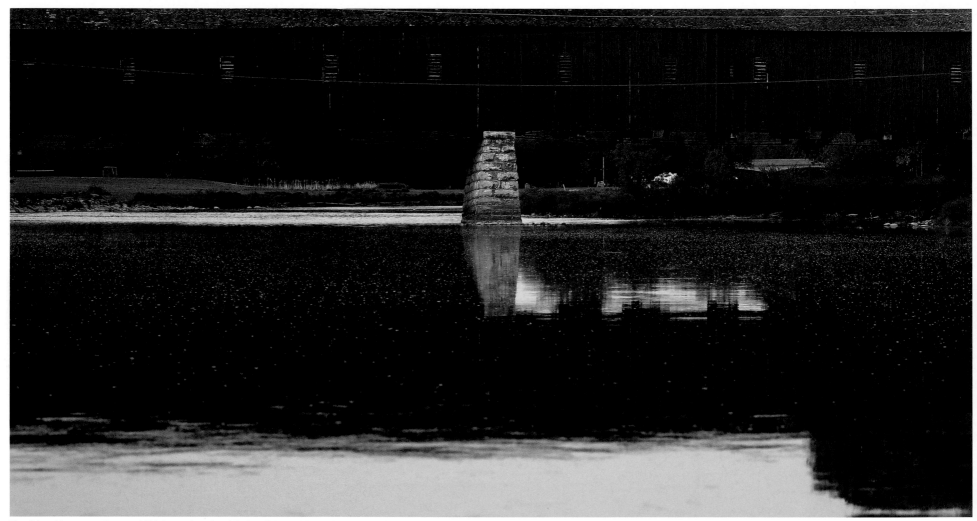

The West Montrose Covered Bridge, a.k.a. the "Kissing Bridge," West Montrose, Ontario

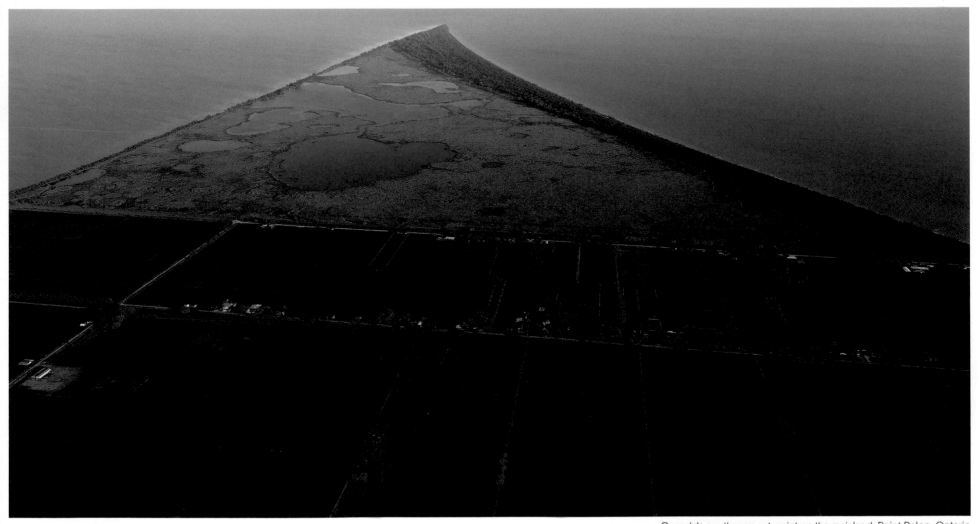

Canada's southernmost point on the mainland, Point Pelee, Ontario

PREVIOUS SPREAD: Thousand Islands Bridge system near Lansdowne, Ontario

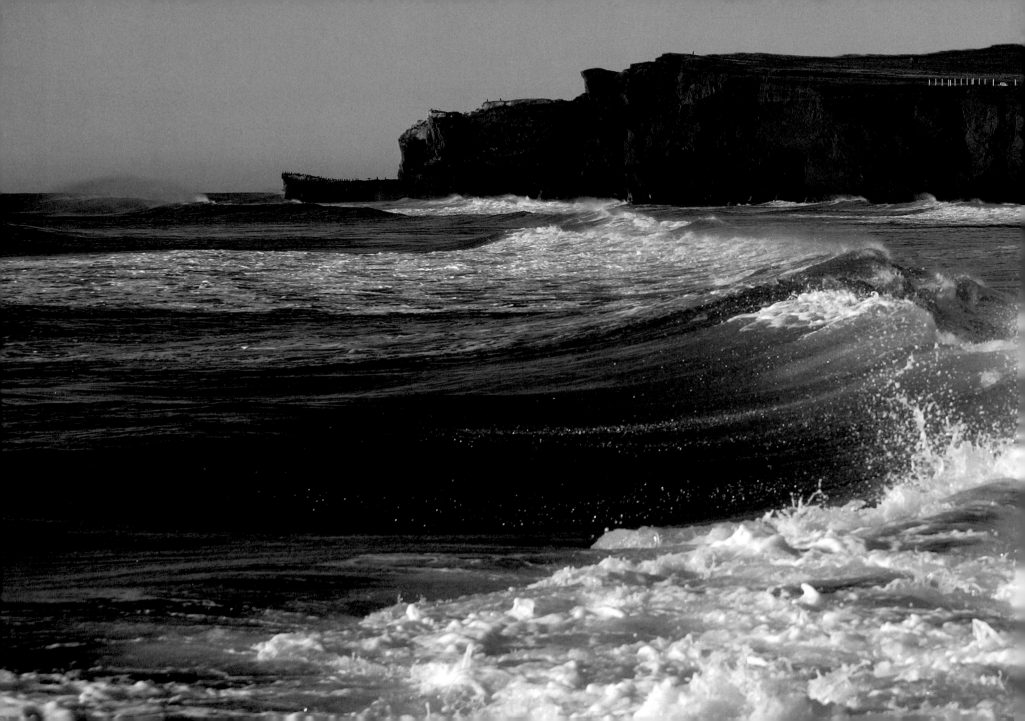

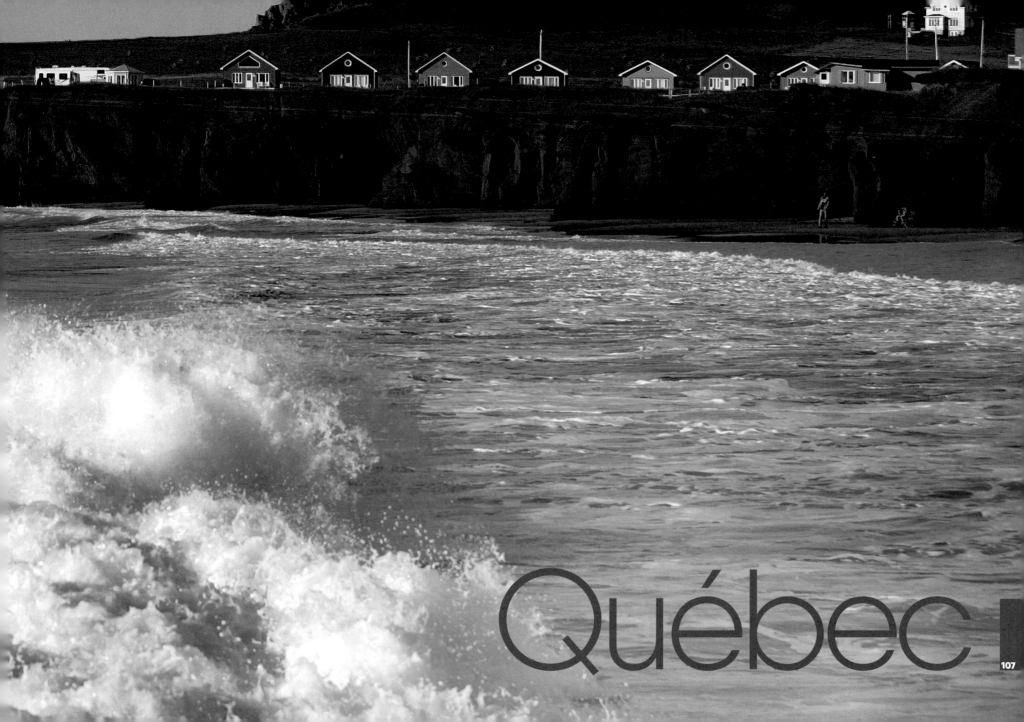

Québec

Québec City, Québec

Let us be French, let us be English, but above all, let us be Canadians!

JOHN A. MACDONALD, FIRST PRIME MINISTER OF CANADA

Québec, Canada's largest province, sits mainly on the Canadian Shield (a large area of exposed Precambrian rock encircling Hudson Bay) and is celebrated for its lush forests, tumbling hills laced with rivers, and mountains worthy of first-class ski resorts. The official language is French with Montréal its largest city and the second-largest French-speaking city in the world (after Paris). Montréal's multicultural and vibrant population is most densely settled around the St. Lawrence River, an important recreational and commercial waterway that flows to the Atlantic Ocean.

The provincial capital, Québec City, is one of the oldest European settlements in North America. Ancient churches keep company with bistros and picturesque shops on cobblestone streets. Year-round festivals and street musicians complement wonderful shopping, restaurants, and an energetic nightlife.

Trek around a little and find the best of each area. Charlevoix offers a good respite from the bustle of the city. Incredibly green valleys sweep you to the beautiful town of Baie-Saint-Paul offering galleries and boutiques along the shores of the St. Lawrence. Tadoussac draws whale-watchers as well as those who would rather kayak, surfbike, or wander along the dunes. Explore the spectacular mountain ranges in the Parc national de la Gaspésie. A well-known landmark, Rocher Percé, close to Île Bonaventure, brings you to North America's largest migratory bird refuge. A short trip to les Îles de la Madeleine (Magdalen Islands) reveals a distinctive archipelago with an impossible amount of beaches. It's easy to get caught up in the Madelinot culture of music, mouthwatering cuisine, and fragile ecology.

"La belle province" will not disappoint in any season. Its unique culture is irresistible for visitors wishing to experience the natural treasures of its many regions.

QC

QUÉBEC

Je me souviens / I remember

One of the founding members of confederation in 1867

Capital: Québec City

Flower: Blue flag iris

Interesting Fact: Québec City is the only walled city in Canada. You can take a tour along the 4.6-kilometre ramparts of this fortified city.

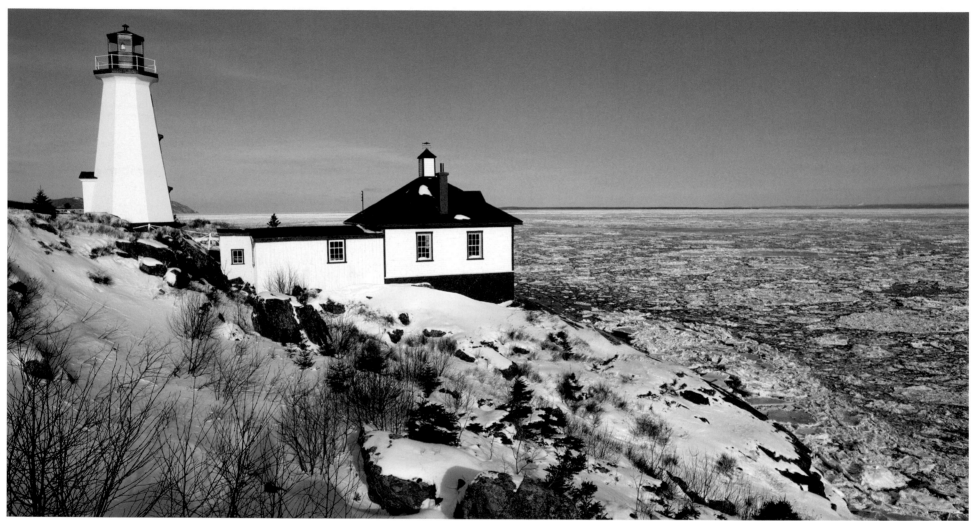

Lighthouse at Cap-au-Saumon, La Malbaie, Québec

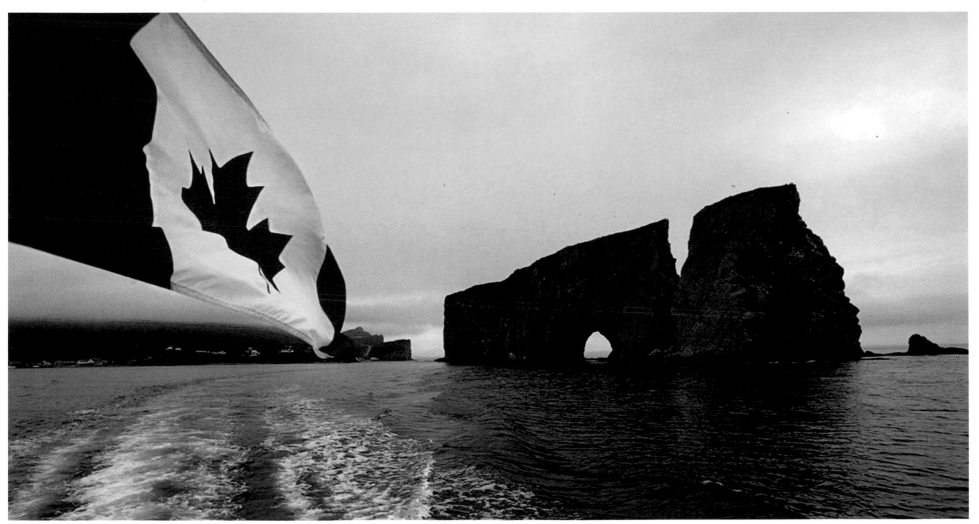

Rocher Percé, Gaspé Peninsula, Québec

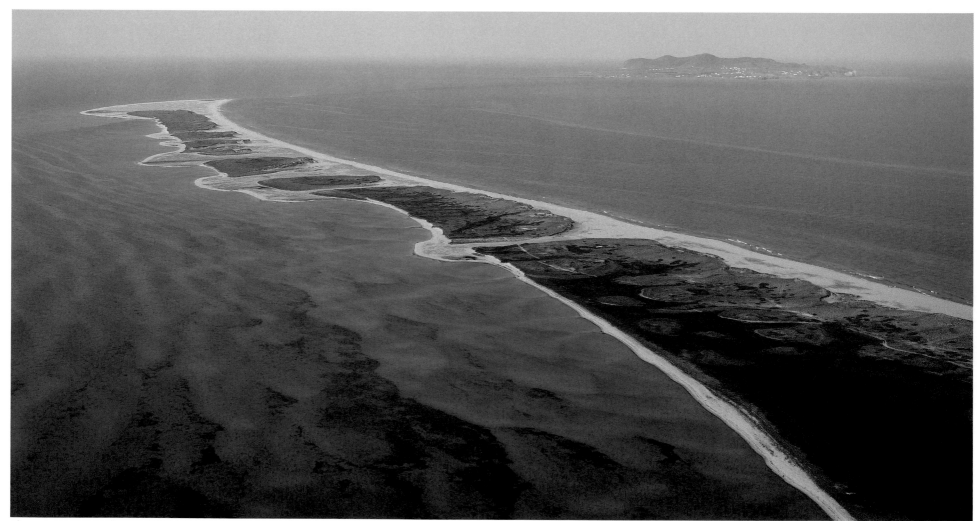

L'Île du Havre Aubert, Îles de la Madeleine, Québec

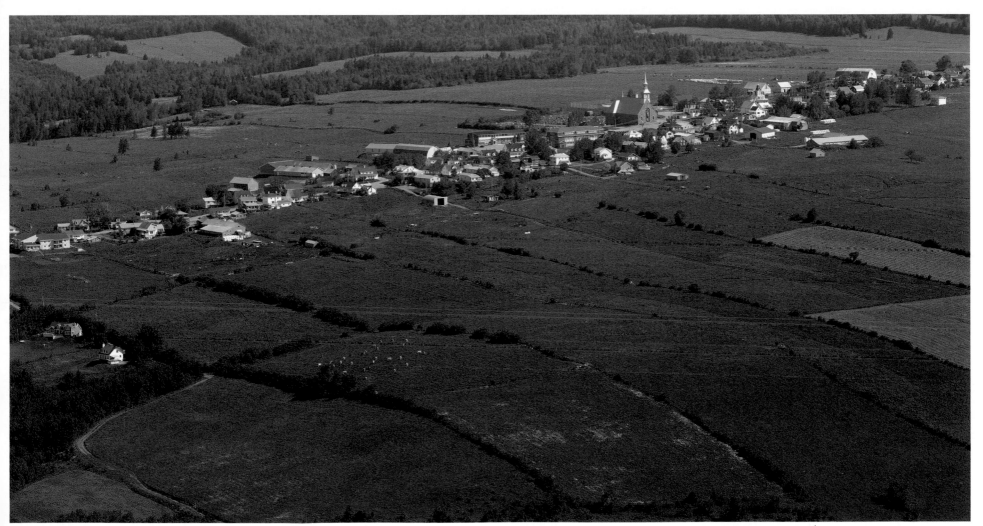

The village of Les Éboulements, Charlevoix, Québec

Mont-Tremblant, Québec

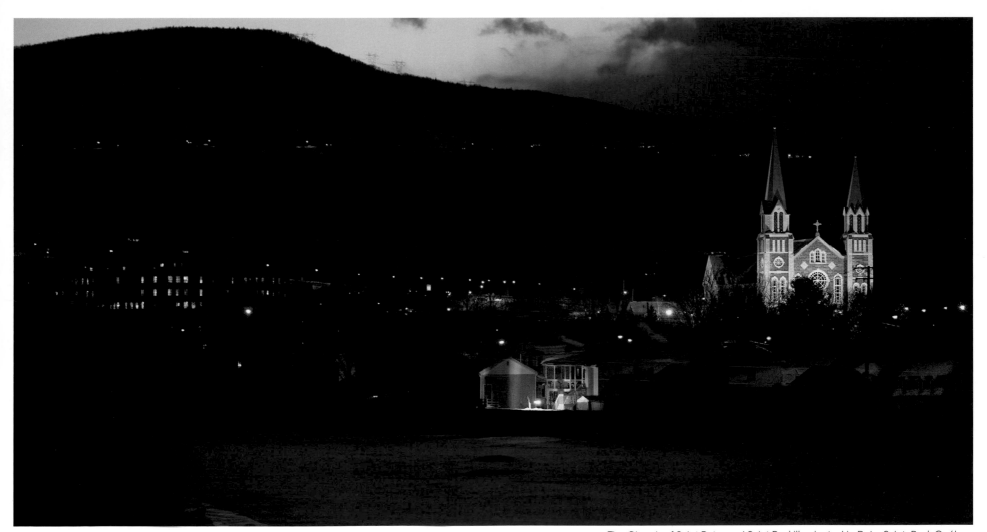

The Church of Saint Peter and Saint Paul illuminated in Baie-Saint-Paul, Québec

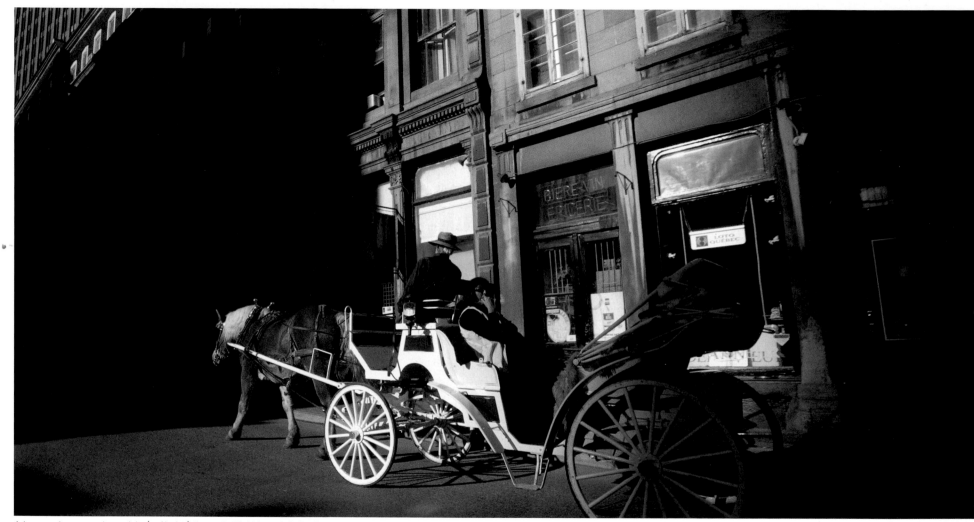

A horse-drawn carriage ride (calèche) through Old Montréal, Québec

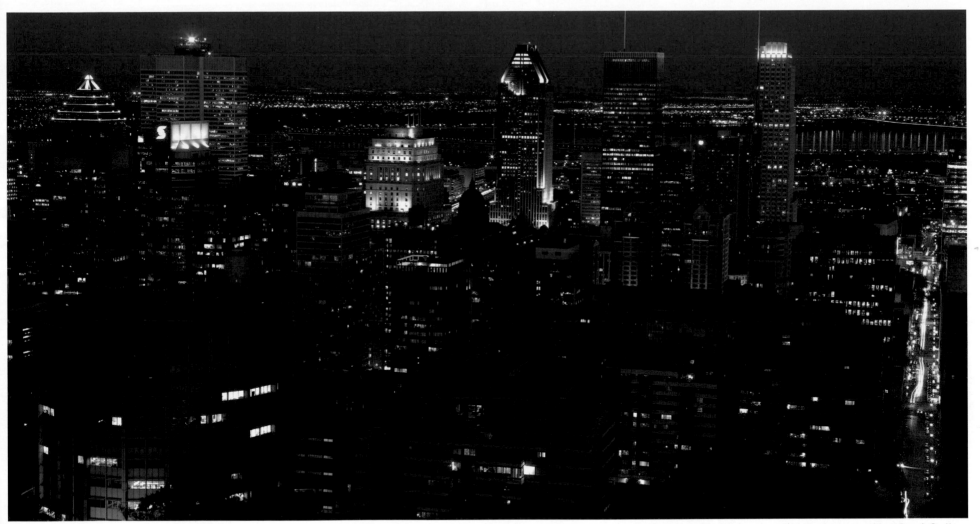

Downtown Montréal as seen from the lookout at Mont Royal, Québec

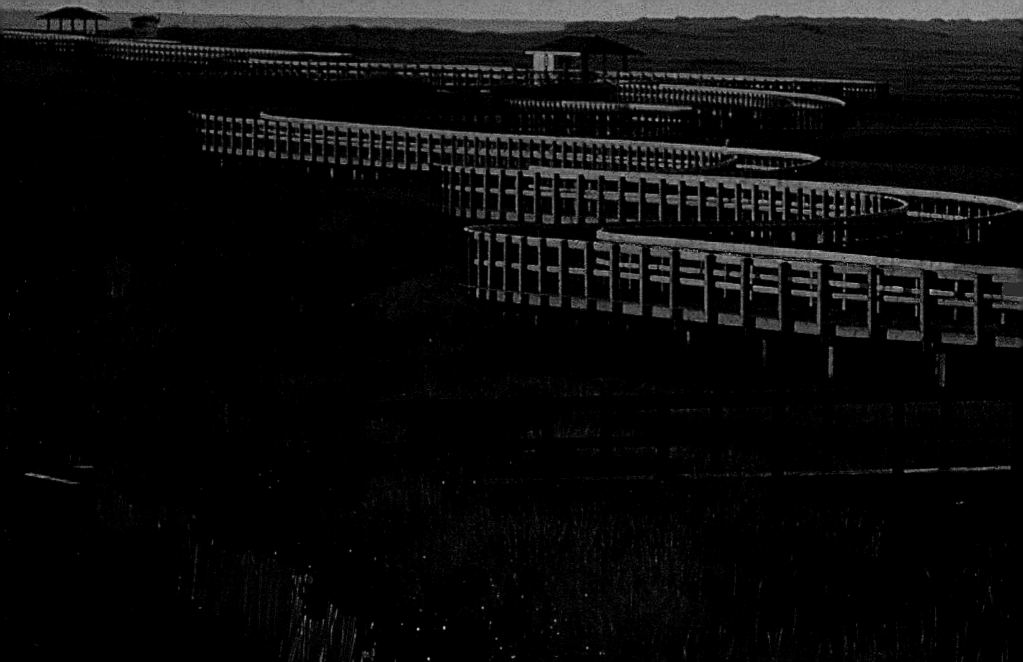

New Brunswick

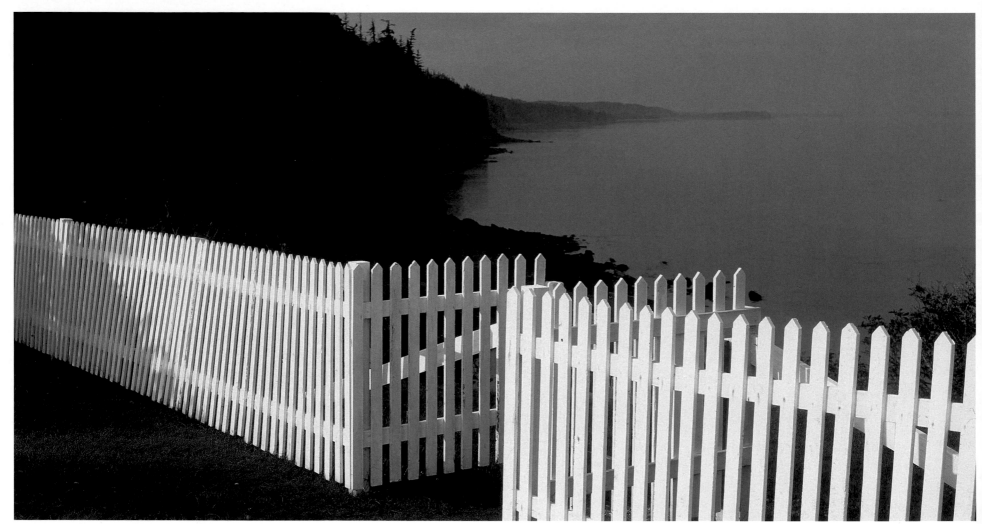

Cape Enrage near Fundy National Park, New Brunswick

A place of contrast, there is evidence New Brunswick dates back to Viking landings. Jacques Cartier made his mark in 1534 followed by Samuel de Champlain in 1604. Today the Mi'kmaq, Maliseet, and Loyalist and Acadian descendants inhabit Canada's only officially bilingual province. Fredericton's Garrison District dates back to 1784 and is a good place to discover its historic British identity. Fort Beauséjour–Fort Cumberland National Historic Site preserves a 1751 French fort for the opposing empire's perspective.

A superb vacation destination, visitors find friendly communities, lively locales with activities in every season, and exceptional natural wonders. Rugged inland peaks drift into valleys and unspoiled wilderness in wide-open spaces of the Maritime Plain. Beautiful terrain encourages exploration through boreal forests or along warm, saltwater shorelines. Clear rivers afford some of the best fishing around.

Travelling down the interior highlands, the Saint John River is forced through a deep gorge where the power of the tides causes the stream to change direction; this creates the Reversing Falls. Tidal Bore Park is a favoured site to watch the phenomenon. At Hopewell Rocks during high tide, paddlers may float among the Flowerpot Rocks; at low tide, they can walk on the ocean floor.

Follow the Fundy Trail Parkway along the southern coast for an incredibly scenic coastal drive. Closer to the Gulf of St. Lawrence, catch a glimpse of Acadian culture in Bouctouche or Caraquet. Make sure to experience the farmers' markets, bursting with local produce and crafts, and catch local events and attractions. Festivities and a fresh lobster dinner are sure to heighten your "joie de vivre." It is well worth taking the time to wander through New Brunswick to appreciate its varied character.

NB NEW BRUNSWICK

Hope restored

One of the founding members of confederation in 1867

Capital: Fredericton

Flower: Purple violet

Interesting Fact: The Bay of Fundy has the highest tides on earth, reaching up to 16 metres – five storeys! – with a flow of 160 billion tonnes of seawater each day.

PREVIOUS SPREAD: La dune de Bouctouche, Bouctouche, New Brunswick

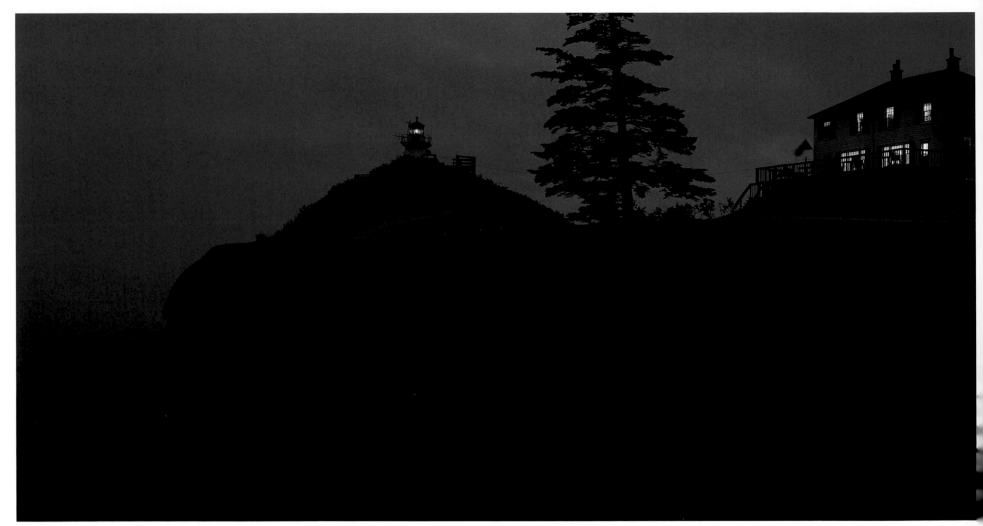

Cape Enrage Lighthouse, Barn Marsh Island, New Brunswick

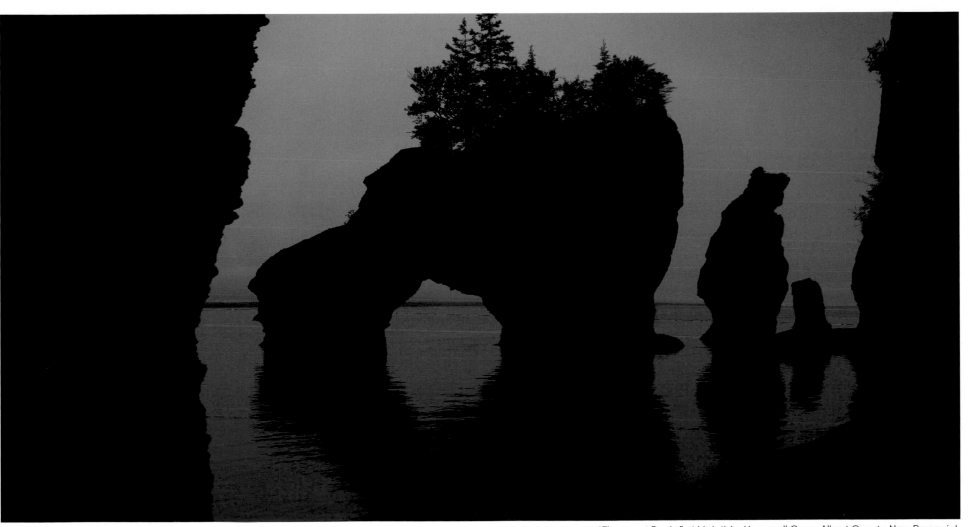

"Flowerpot Rocks" at high tide, Hopewell Cape, Albert County, New Brunswick

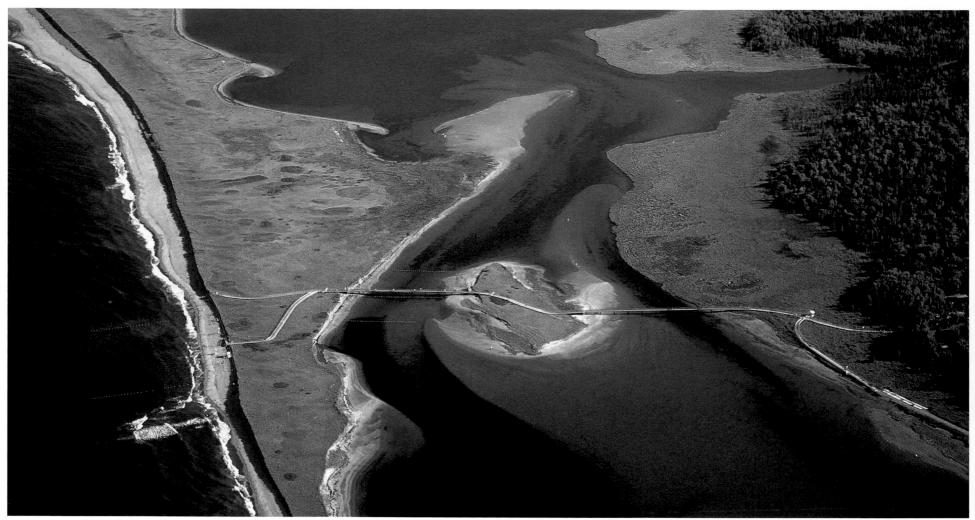

Kouchibouguac National Park, Kent, New Brunswick

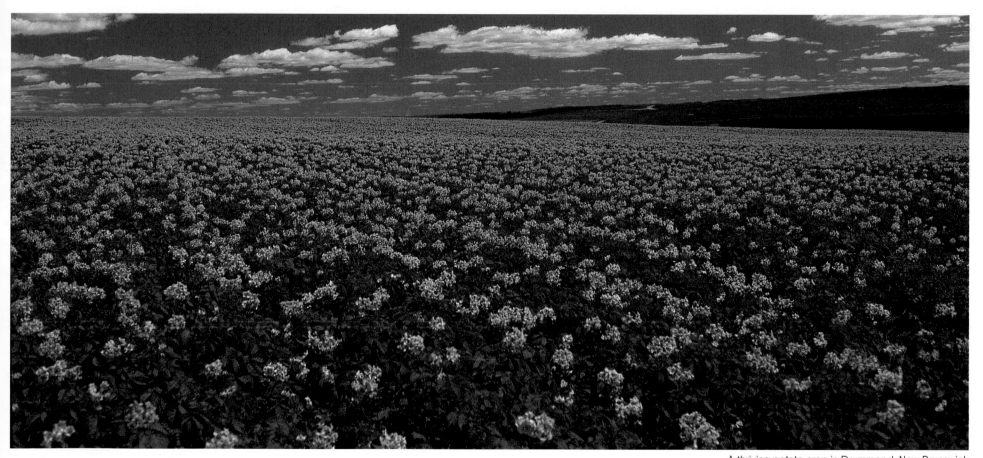

A thriving potato crop in Drummond, New Brunswick

Our hopes are high. Our faith in the people is great. Our courage is strong.
And our dreams for this beautiful country will never die.

PIERRE ELLIOTT TRUDEAU, FORMER PRIME MINISTER OF CANADA

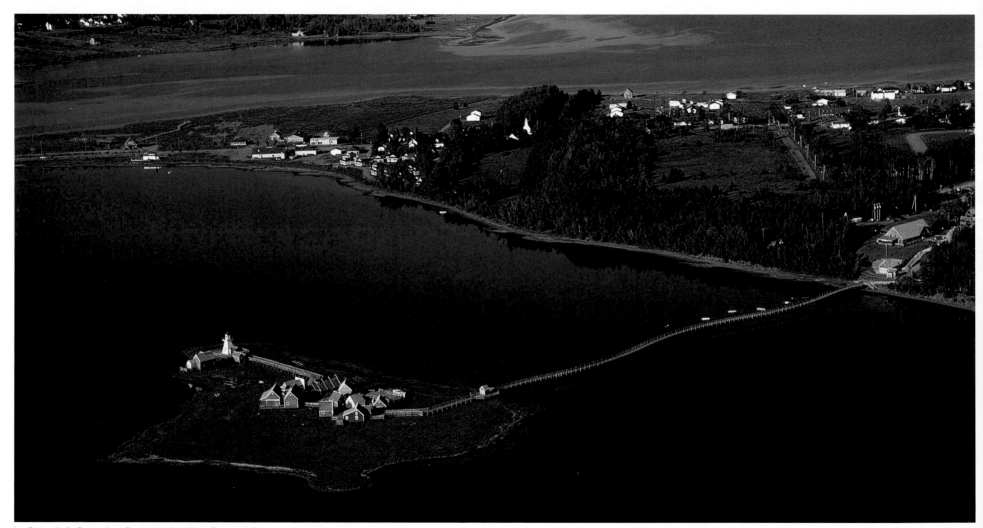

Le Pays de la Sagouine, Bouctouche, New Brunswick

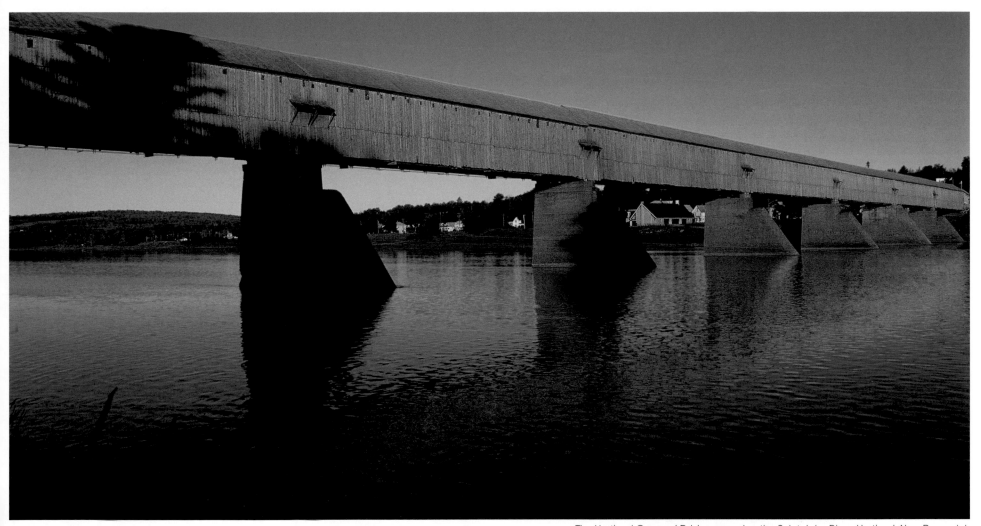

The Hartland Covered Bridge spanning the Saint John River, Hartland, New Brunswick

PREVIOUS SPREAD: The Bay of Fundy near Cape Enrage, New Brunswick

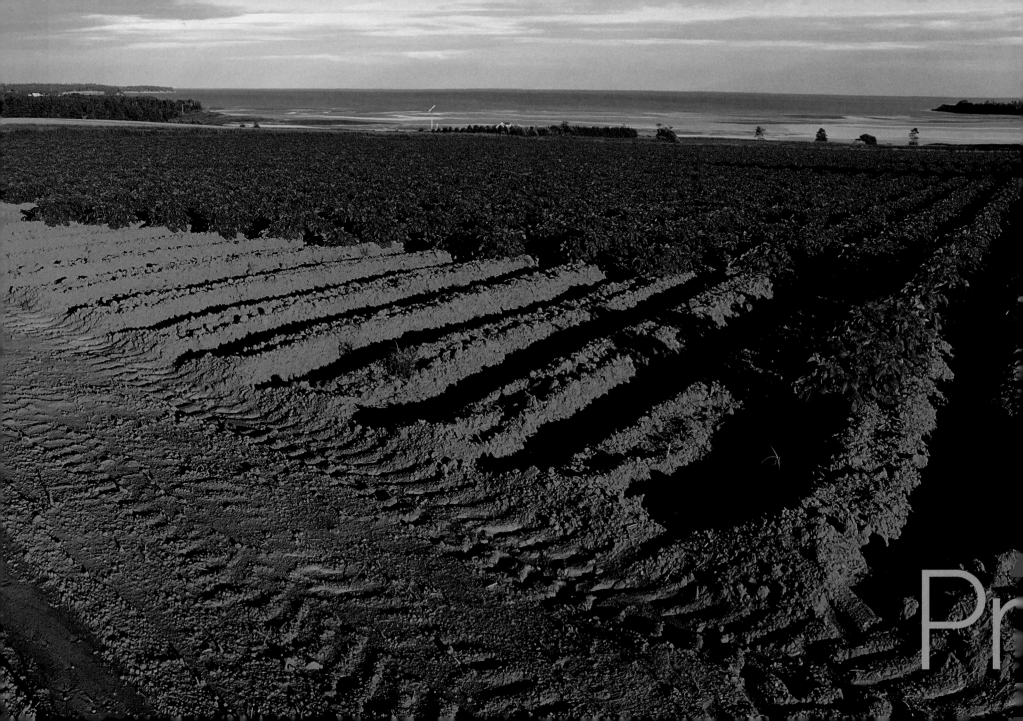

nce Edward Island

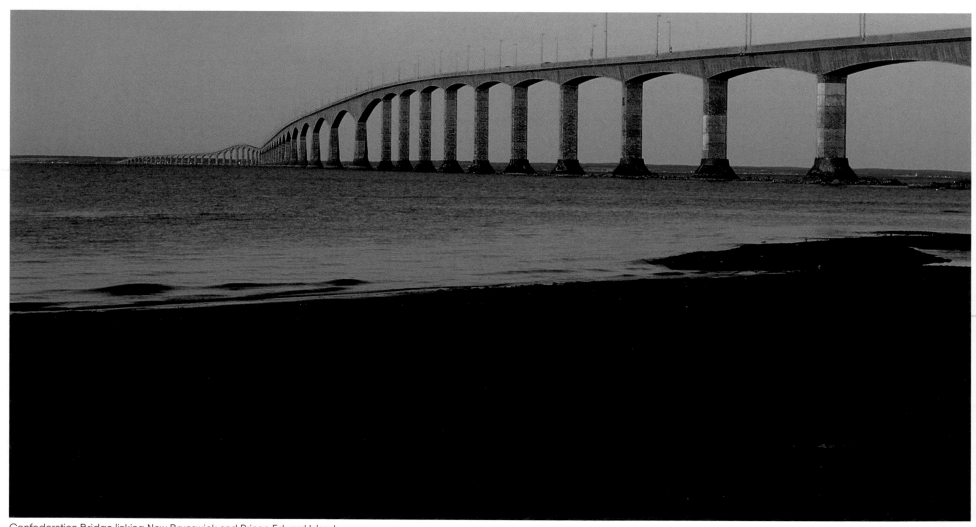

Confederation Bridge linking New Brunswick and Prince Edward Island

Originally known to the Mi'kmaq as *Epekwitk*, meaning "cradled on the waves," PEI was renamed Île Saint-Jean when Jacques Cartier claimed it as a French colony and part of Acadia in 1534. After the Seven Years' War in 1763, it became St. John's Island under Great Britain's control. Its present name was settled by request of Edmund Fanning, second governor of the island, in honour of Prince Edward Augustus (who later became the father of Queen Victoria), to distinguish it from similar John-like names in the Maritimes.

The smallest province in Canada, almost half of PEI's land is cleared for agriculture. The fertile, vivid, red soil (created by iron oxide) has become a symbol of the province and has earned the island the nickname "Garden of the Gulf." It is connected to New Brunswick by the famous 12.9-kilometre Confederation Bridge and to Nova Scotia via the Wood Islands ferry.

A scenic drive or leisurely bike tour, perhaps along Confederation Trail, will inevitably lead to lighthouses and seaports each distinct for the region. The rugged North Cape turns into the colourful city of Summerside in the west with artisans and a quiet waterfront. Bright green hills contrast with hues of red sandstone cliffs on the edge of picture-perfect vistas and incomparable coastline. Singing Sands beach at Basin Head in the east is a favourite. Camping or renting a seaside cottage is the perfect way to relax to the sounds of the waves and catching a star-studded canopy at the end of the day.

Cavendish, the magical setting for the *Anne of Green Gables* novels, has attracted millions of "kindred spirits." The storybook charm of the area has fostered a thriving theatrical adaptation which graces stages all across the province. Exciting festivals and island flavours are never far from stunning ocean views and sweeping coastline. It all comes together in Prince Edward Island.

PRINCE EDWARD ISLAND

The small protected by the great

Joined confederation in 1873

Capital: Charlottetown

Flower: Lady's slipper

Interesting Fact: The Confederation Bridge was built in 1997 to link Prince Edward Island with mainland Canada at New Brunswick. At 12.9 kilometres it is the longest bridge in the world over ice-covered water.

PREVIOUS SPREAD: Fortune Bridge, Prince Edward Island

Rollo Bay, Prince Edward Island

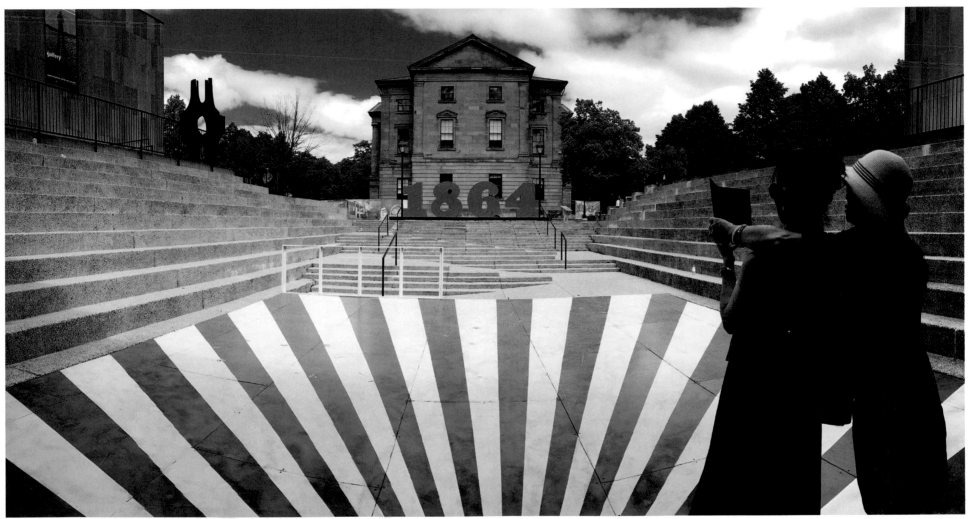

PEI Legislature, Charlottetown, Prince Edward Island

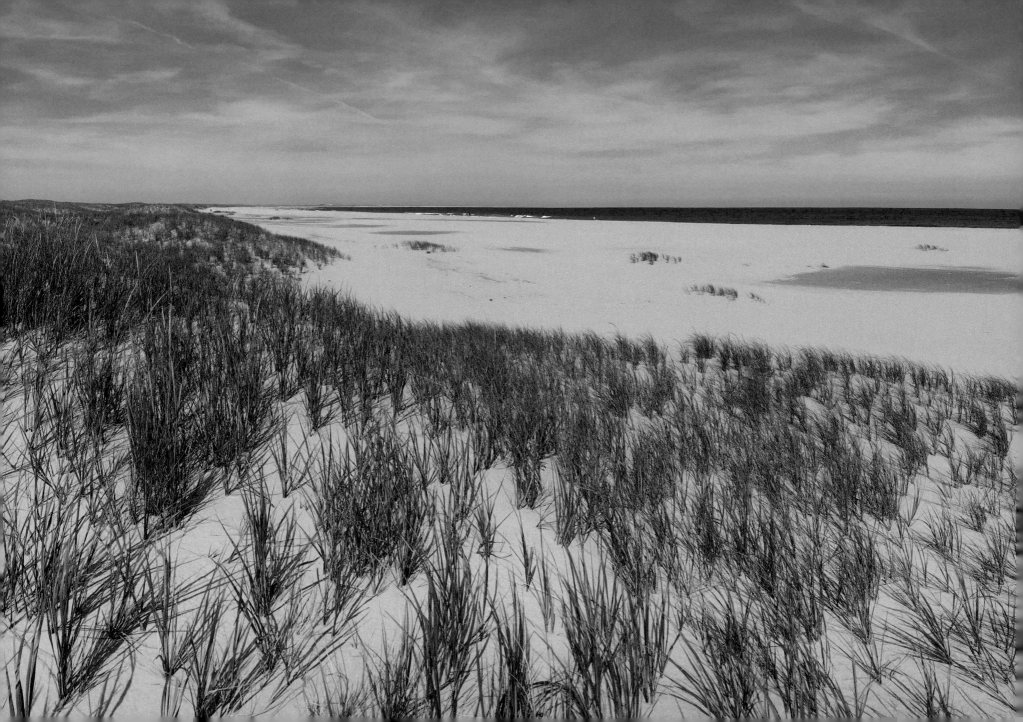

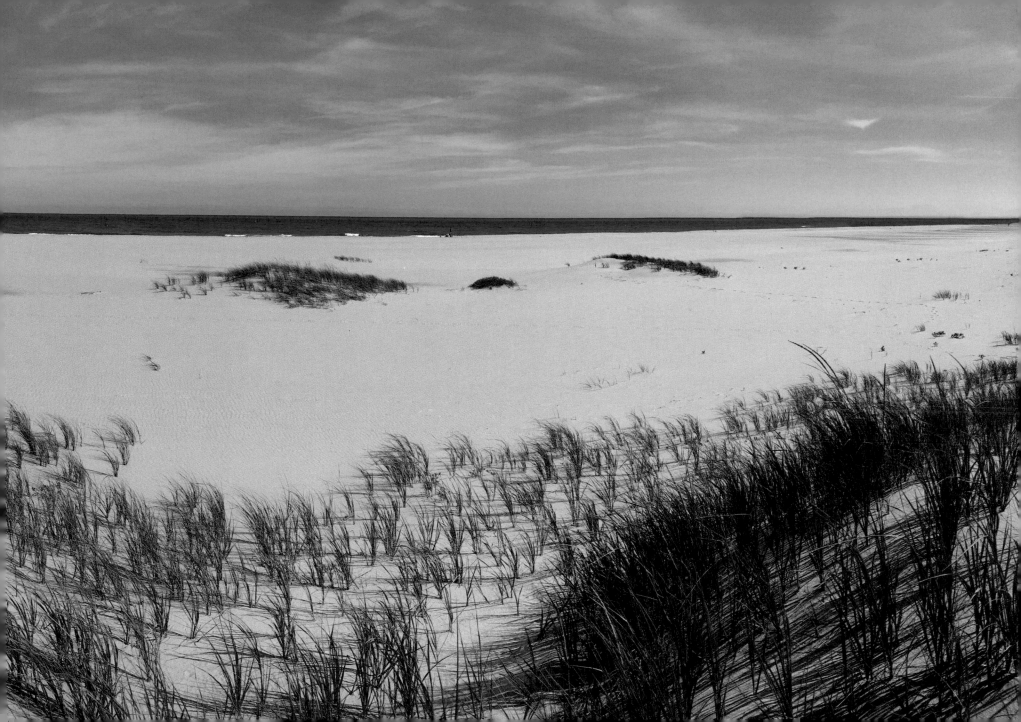

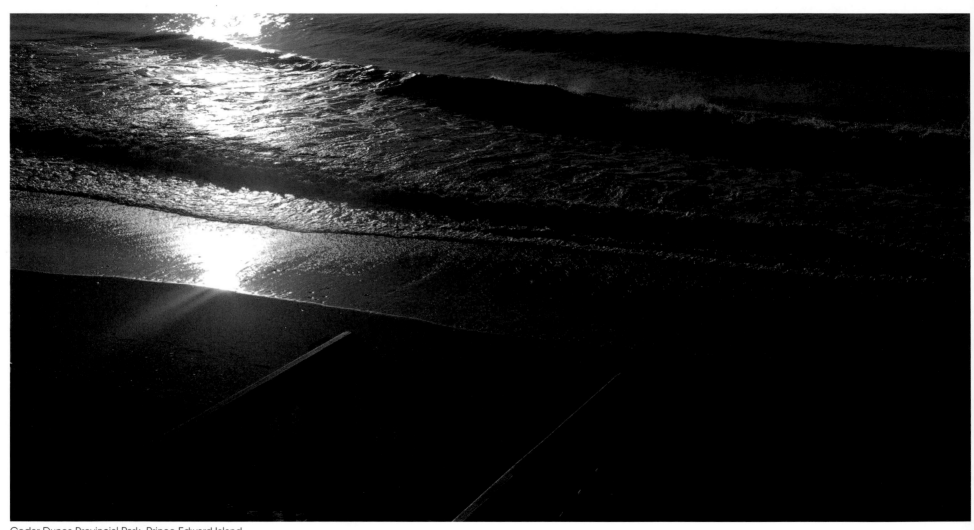

Cedar Dunes Provincial Park, Prince Edward Island

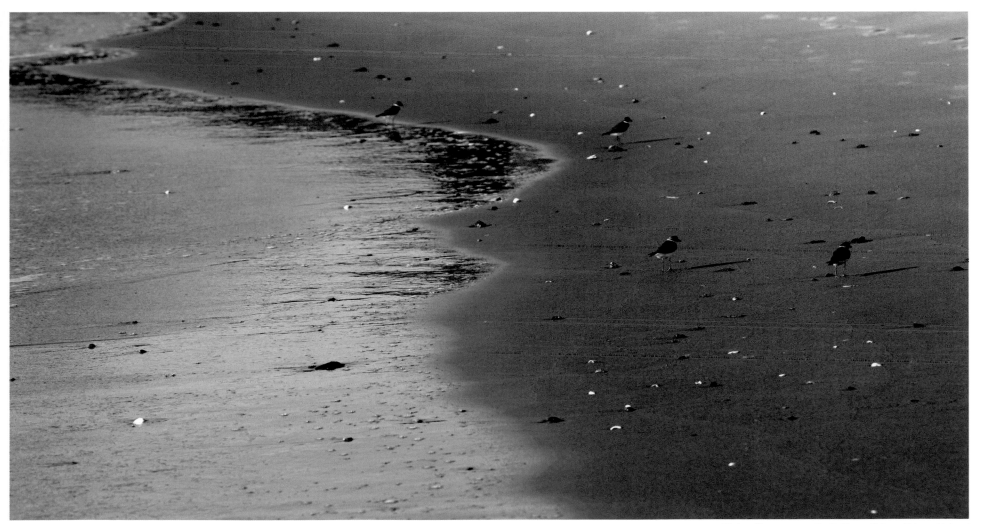

Piping Plovers near North Cape, Prince Edward Island

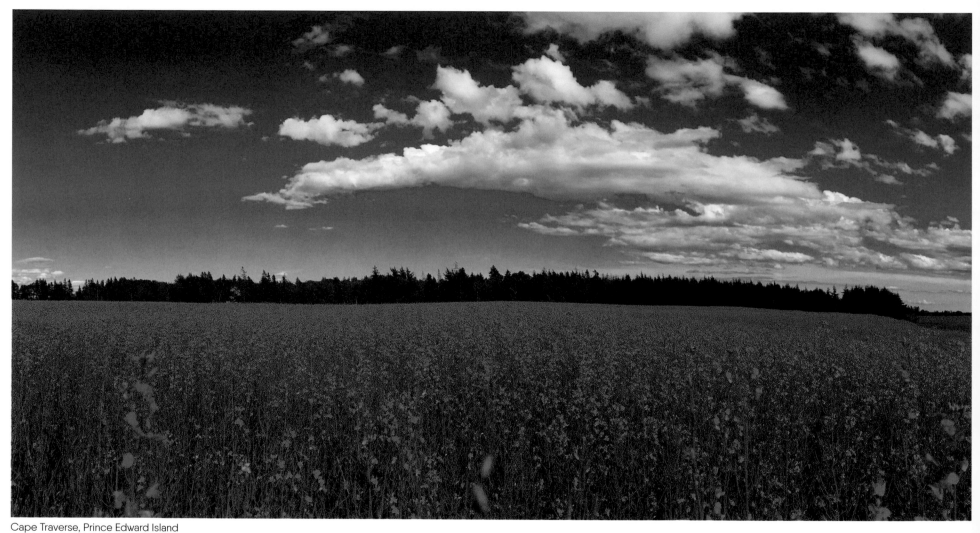

Cape Traverse, Prince Edward Island

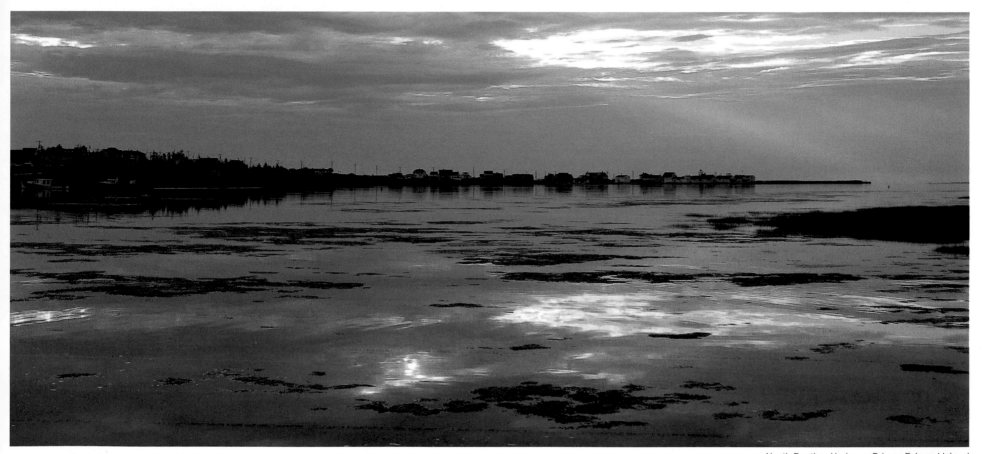

North Rustico Harbour, Prince Edward Island

I love Canada. It's a wonderful political act of faith
that exists atop a breathtakingly beautiful land.

YANN MARTEL, AUTHOR

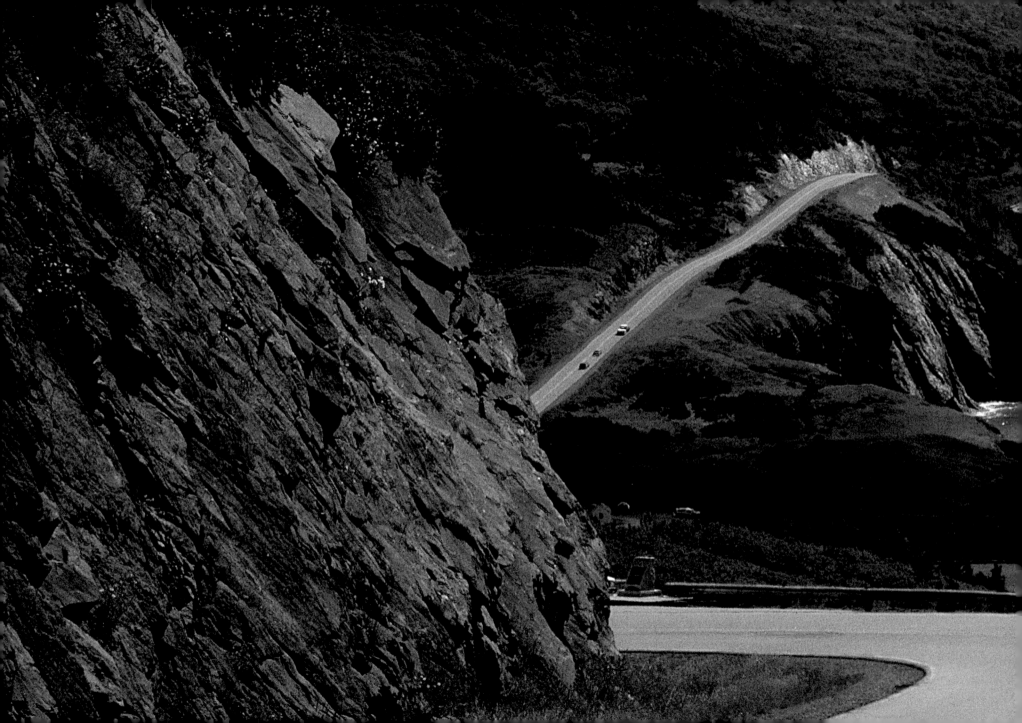

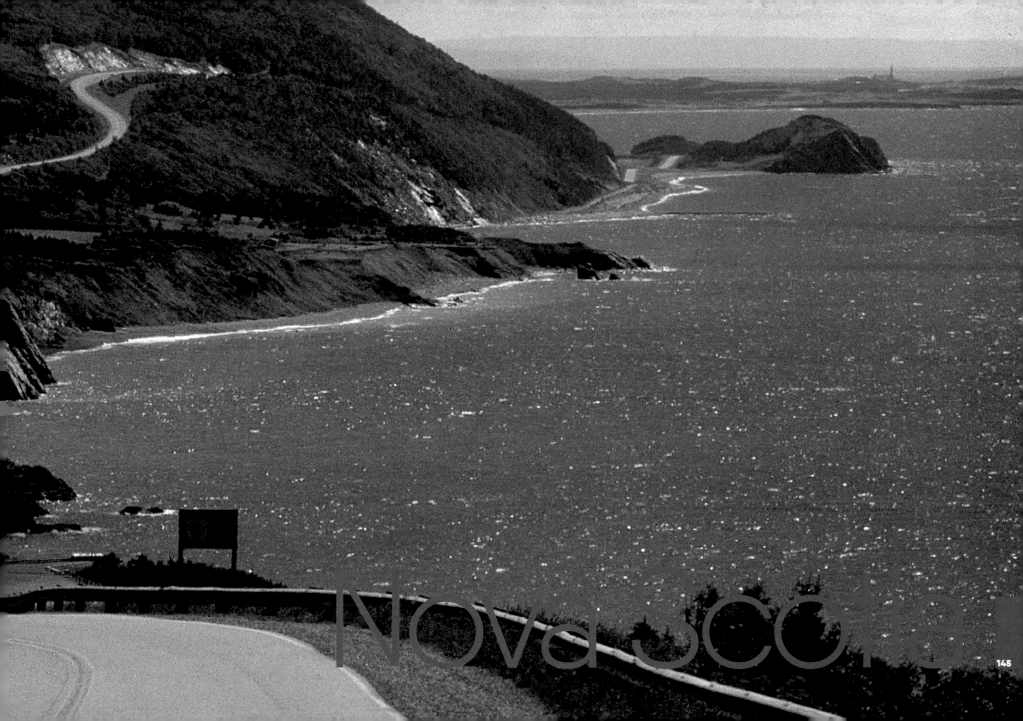

Nova Scotia

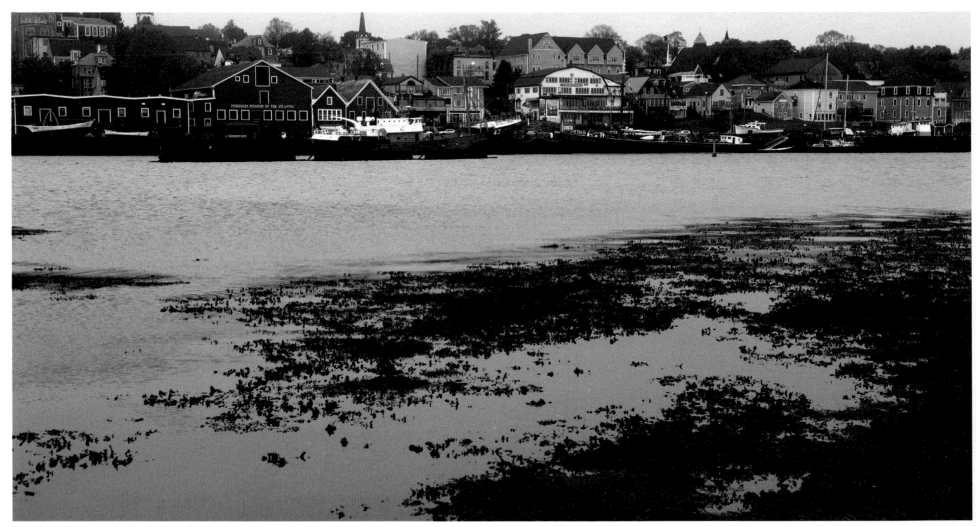

Lunenburg, Fairhaven Peninsula, Nova Scotia

Almost completely surrounded by the North Atlantic Ocean, Nova Scotia hangs on the southeastern edge of Canada's mainland where the power of nature is respected and its beauty celebrated. A welcoming and resilient people greet visitors, eager to affirm the charm of their province.

The rich culture of the Mi'kmaq is the base of the province's historic identity. The French, who first came in 1604, settled amicably; however, several sizable battles for control followed during the 1600s and 1700s between the English, Scottish, Dutch, and French. The long unrest ended in 1761 with the Burying the Hatchet Ceremony, a commitment to peace between Great Britain and the Mi'kmaw people.

Proximity to the ocean has also positioned Nova Scotia as an entry point for waves of immigration. The Celtic culture from Ireland and Scotland is obvious in certain place names, plus a good cèilidh is never far away. The African Nova Scotian community tells its own story, weaving through time, from Samuel de Champlain and the Mi'kmaq to those escaping persecution and slavery in the south via the Underground Railroad. The Acadian people also have a long history here, and French-speaking villages dotted throughout the province contribute to the diverse cultural mosaic. Nova Scotia has created a centre for internationally renowned arts and literature, famous music, and unsurpassed cuisine (especially seafood).

As a crucial harbour, its heritage is befitting a military stronghold and safe haven. The past comes to life in the forts and national historic sites. A look into natural resources leads to the coal mines of Cape Breton and an authentic underground adventure. The Cabot Trail winds through 300 kilometres of spectacular rugged coastline for a stimulating hike or a leisurely road trip. A change of pace opens in the rolling hills of the wine region of the Annapolis Valley. The Good Cheer Trail can also lead to side trips of beaches, farmland, and a great escape in a charming town. Visitors can follow their passion in many ways. Wildlife parks and zoos or whale watching and puffin tours focus on inspiring views of the animal kingdom. For some excitement, the tidal bore gives one-of-a-kind thrill rides powered by the Bay of Fundy tide. "Canada's ocean playground" offers interesting possibilities down every road — where you are never more than 67 kilometres from the ocean.

NS NOVA SCOTIA

One defends and the other conquers

One of the founding members of confederation in 1867

Capital: Halifax

Flower: Mayflower

Interesting Fact: Nova Scotia's tall ship sailing ambassador, the *Bluenose II*, is a replica of the original *Bluenose* that retired undefeated after seventeen years in the International Fisherman's Trophy race and was named Queen of the North Atlantic fishing fleet. Represented on the Canadian dime, the ships were named for "Bluenosers," the nickname of Nova Scotians, although the origin of the moniker is unclear.

PREVIOUS SPREAD: The Cabot Trail, Cape Breton Highlands National Park, Nova Scotia

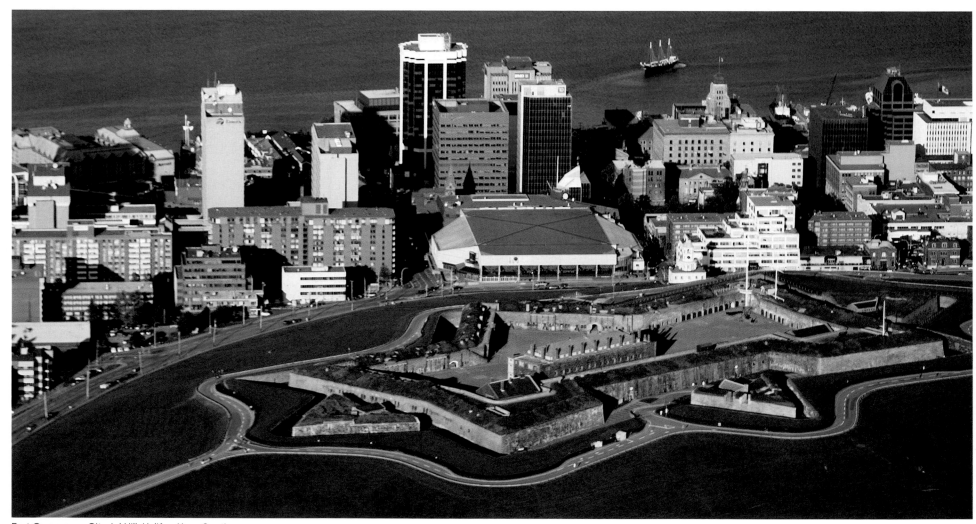

Fort George on Citadel Hill, Halifax, Nova Scotia

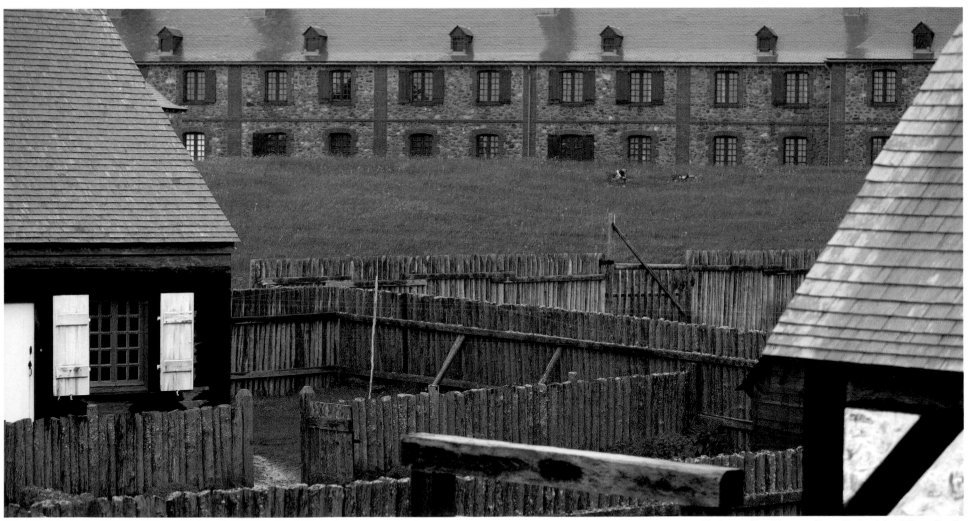

Fortress of Louisbourg, Cape Breton Island, Nova Scotia

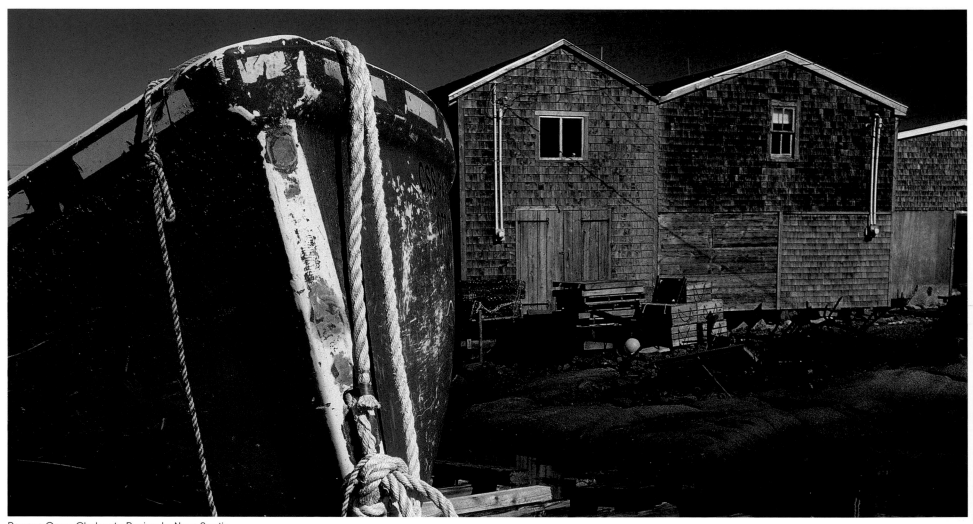

Peggys Cove, Chebucto Peninsula, Nova Scotia

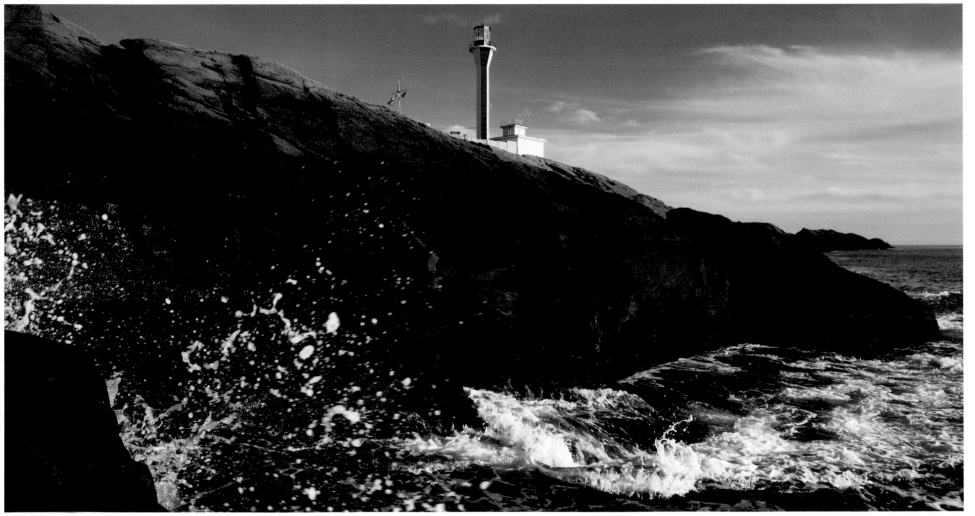

Lighthouse on Cape Forchu, Yarmouth, Nova Scotia

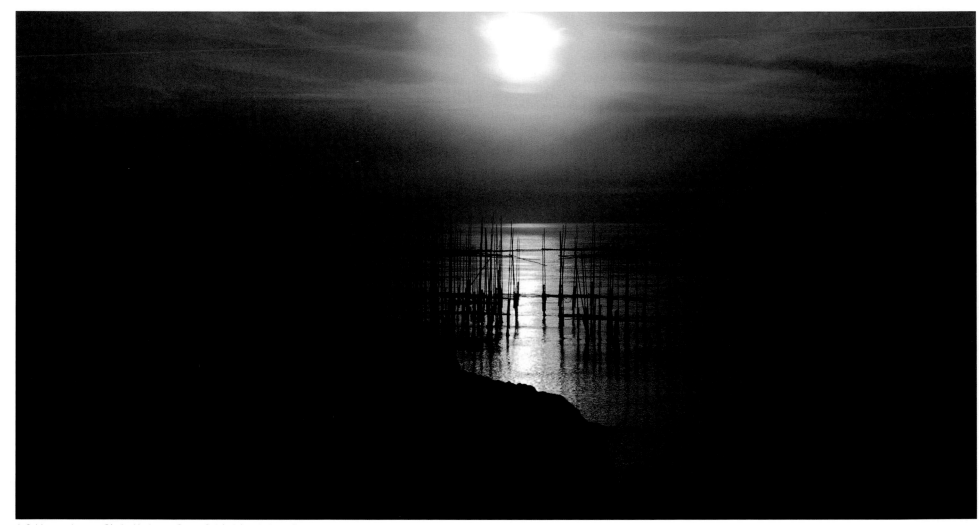

A fishing weir near Clarks Harbour, Cape Sable Island, Nova Scotia

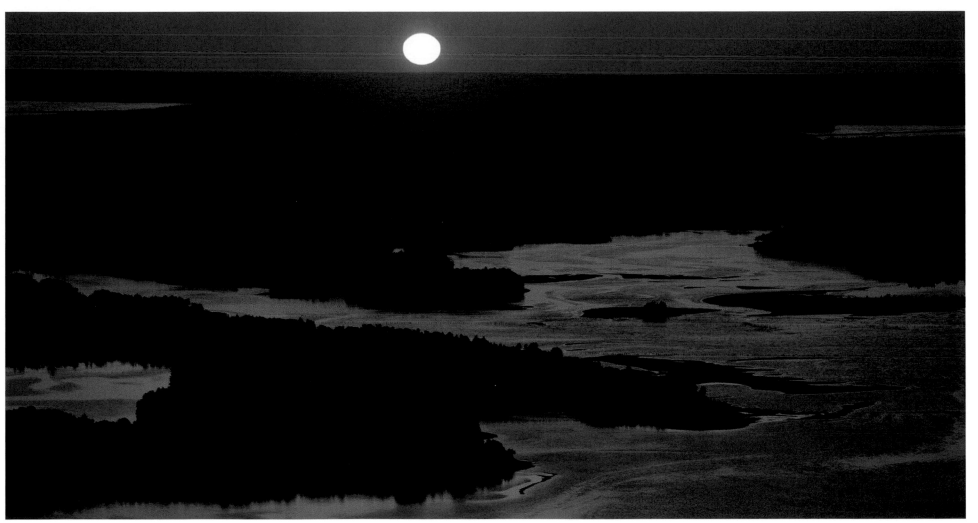

An inland sea at Bras d'Or Lake, Cape Breton Island, Nova Scotia

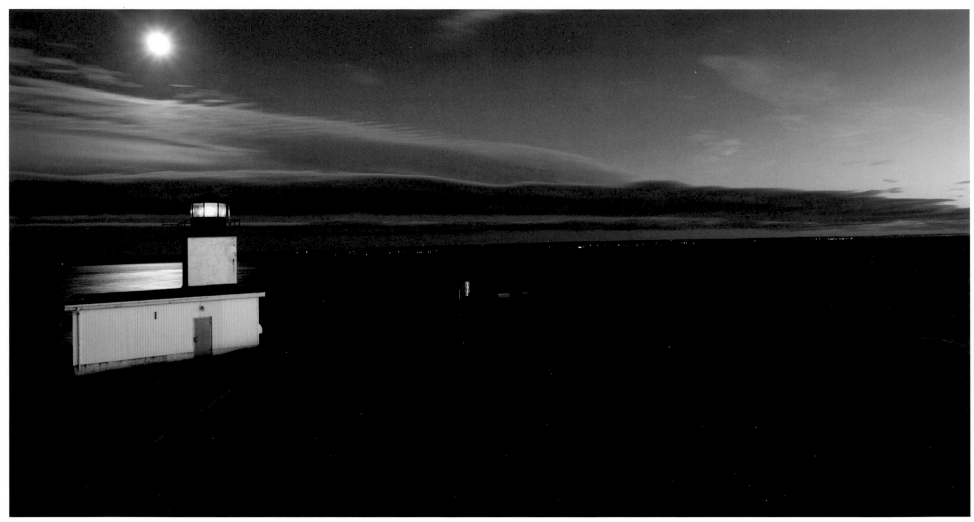

Lighthouse on Cape d'Or, Cumberland County, Nova Scotia

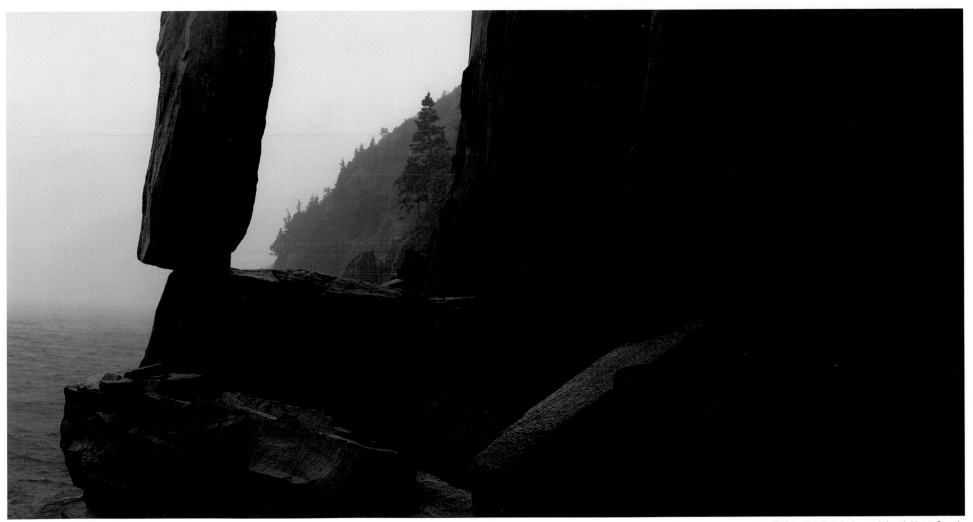

Balancing Rock, Long Island, Nova Scotia

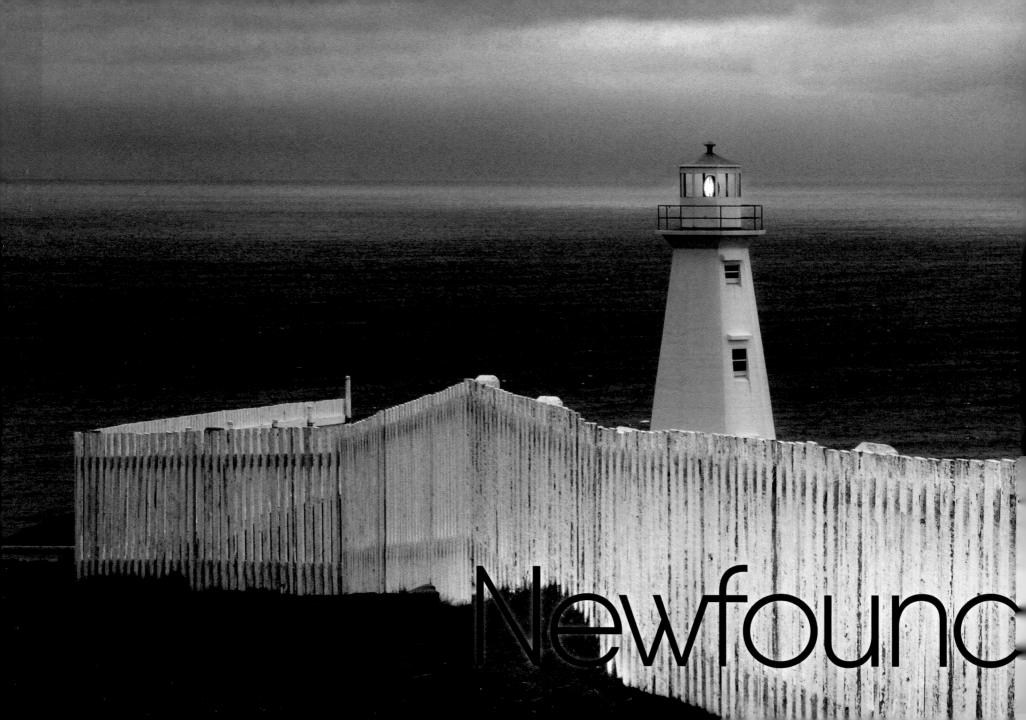

Newfound

and and Labrador

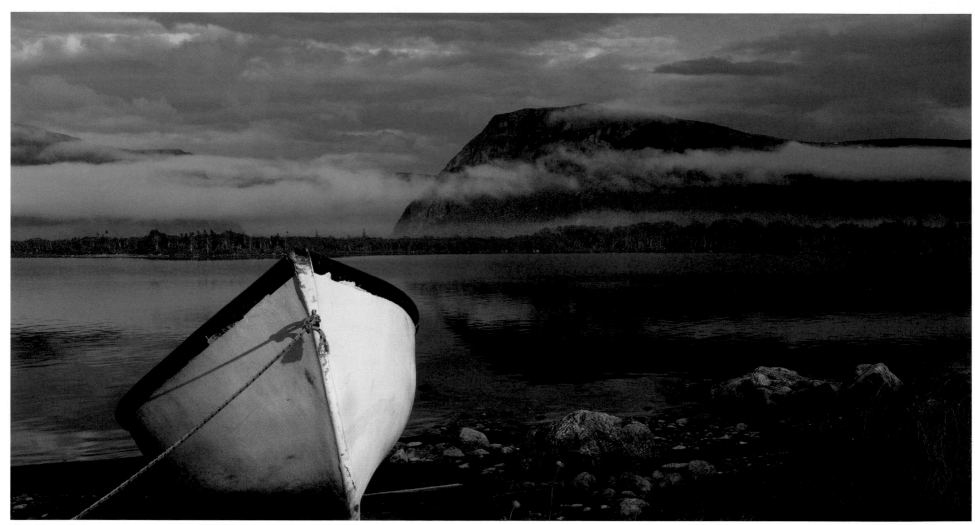

Gros Morne National Park, Newfoundland and Labrador

Embracing life, Canada's newest province with the oldest city (St. John's) follows its own rhythm. Warm, hospitable residents speak with unique accents that vary by region. Even the Newfoundland and Labrador time zone is unconventional: thirty minutes ahead of Atlantic Standard Time. British celebrations like Guy Fawkes Day in November and Mummers at Christmas are embraced here – although most of Canada has no idea what it's all about.

Less than 10 percent of the population lives in Labrador, the large mainland portion of the province. At its southeast corner, the Strait of Belle Isle separates it from the island of Newfoundland. "The Rock" has delightful place names like Blow Me Down, Cow Head, and Heart's Content that keep travellers wondering what's around the next corner. Both ancient Dorset and Beothuk culture existed here before European explorers, but the best-preserved historical settlement is at L'Anse aux Meadows, where an authentic Viking encampment is recreated.

National parks provide easy access to amazing highlights. Gros Morne National Park maps awesome hiking trails and excursions while Cape St. Mary's Ecological Reserve is the nesting site of thousands of birds. At Cape Spear visitors can rest at the easternmost tip of North America. Rocky beaches for whale watching, iceberg-spotting, and lighthouse photo ops are available in more places than can be mentioned. Museum visits or shopping trips fill the days, while nights brim with foot-stomping music and a snack of scrunchions, or a trendy restaurant and a walk by the colourful houses of Jellybean Row. A trip to Signal Hill with its breathtaking vantage point over St. John's Harbour is a must. Cabot Tower is a fortress of military history and also the site where Guglielmo Marconi received the first transatlantic wireless message, in 1901.

Those who immerse themselves in the proud maritime culture in any season will quickly learn to seek out a boil up – Jigg's dinner – fish and brewis, and cod tongues, You'll be "havin' a time b'y."

NEWFOUNDLAND AND LABRADOR

Seek ye first the kingdom of God

Joined confederation in 1949

Capital: St. John's

Flower: Pitcher plant

Interesting Fact: North America's oldest funeral monument, belonging to the indigenous people of Labrador, was constructed 3,000 years before the Egyptian pyramids.

PREVIOUS SPREAD: Cape Spear, Avalon Peninsula, Newfoundland and Labrador

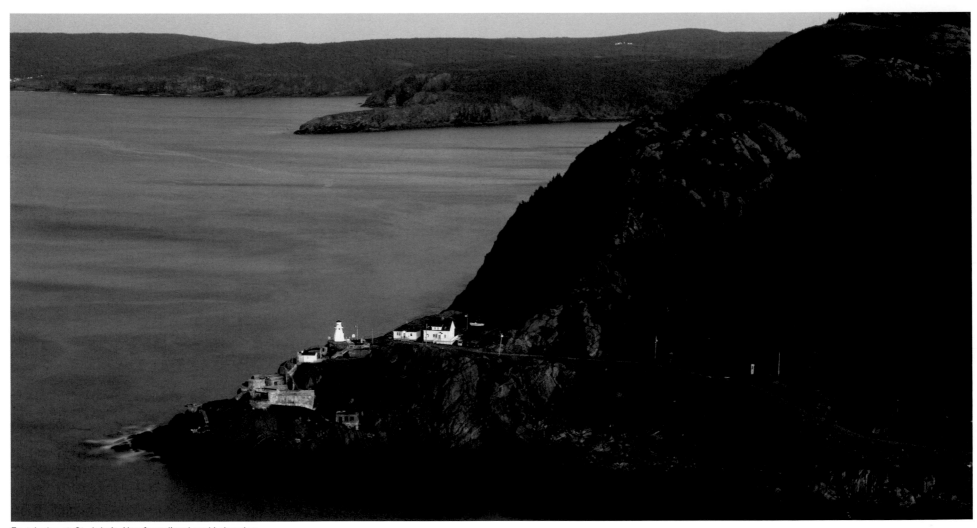

Fort Amherst, St. John's, Newfoundland and Labrador

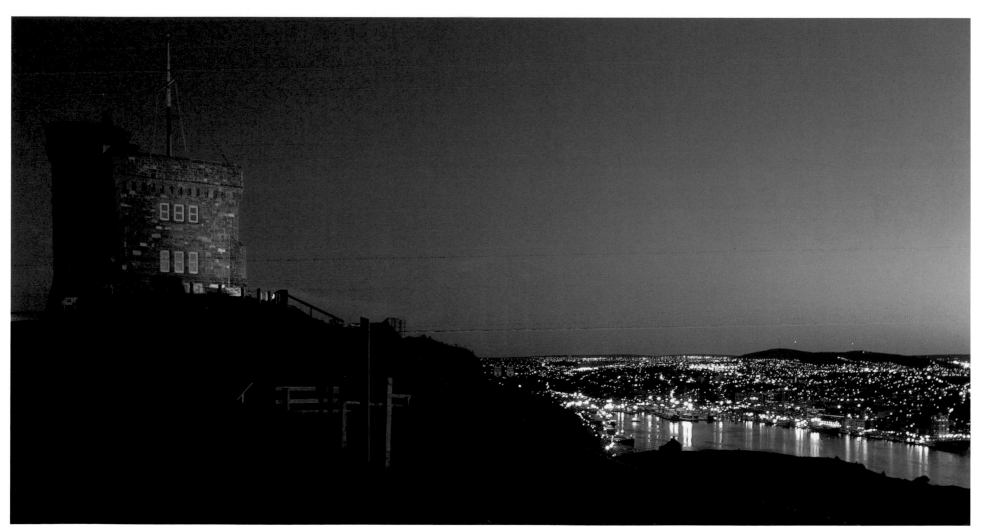

Signal Hill overlooking St. John's, Newfoundland and Labrador

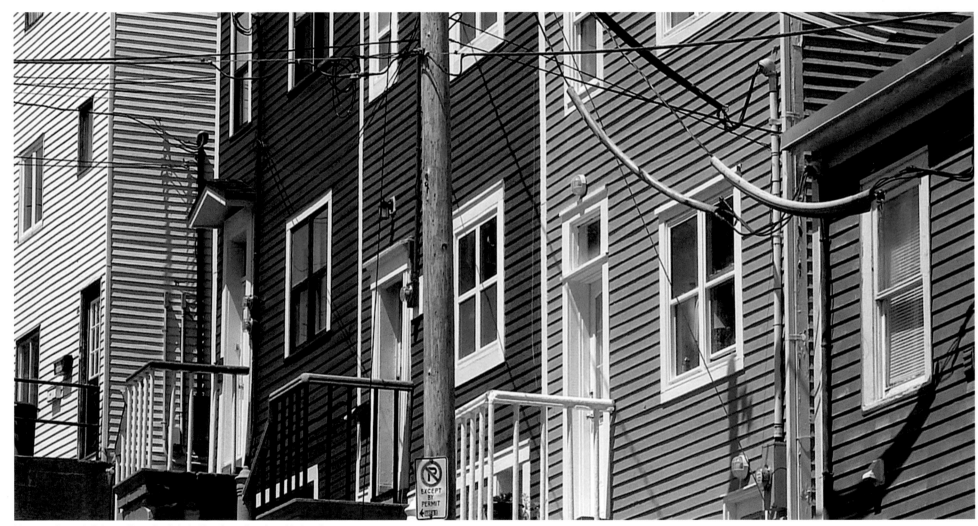

Houses along Jellybean Row, St. John's, Newfoundland and Labrador

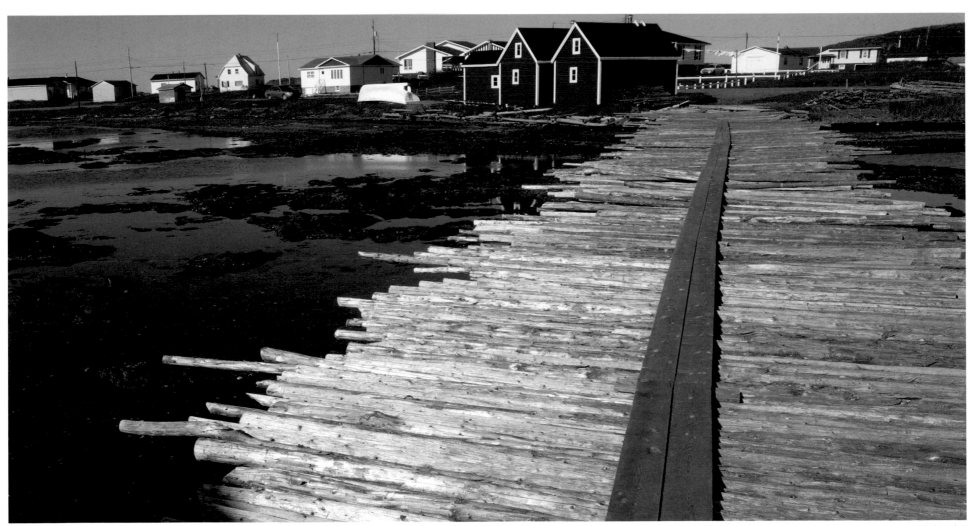
Fishing wharves and stages on Ha Ha Bay, Great Northern Peninsula, Raleigh, Newfoundland and Labrador

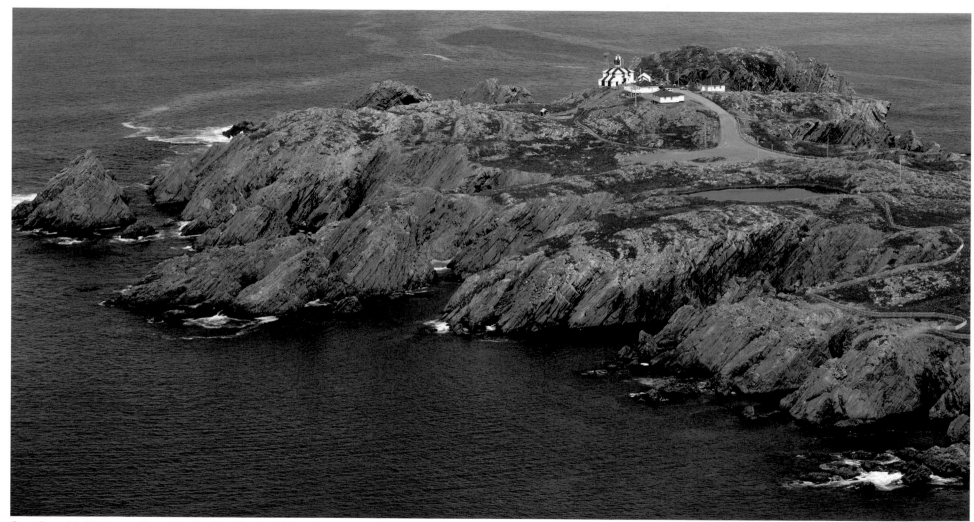

Cape Bonavista Lighthouse, Bonavista, Newfoundland and Labrador

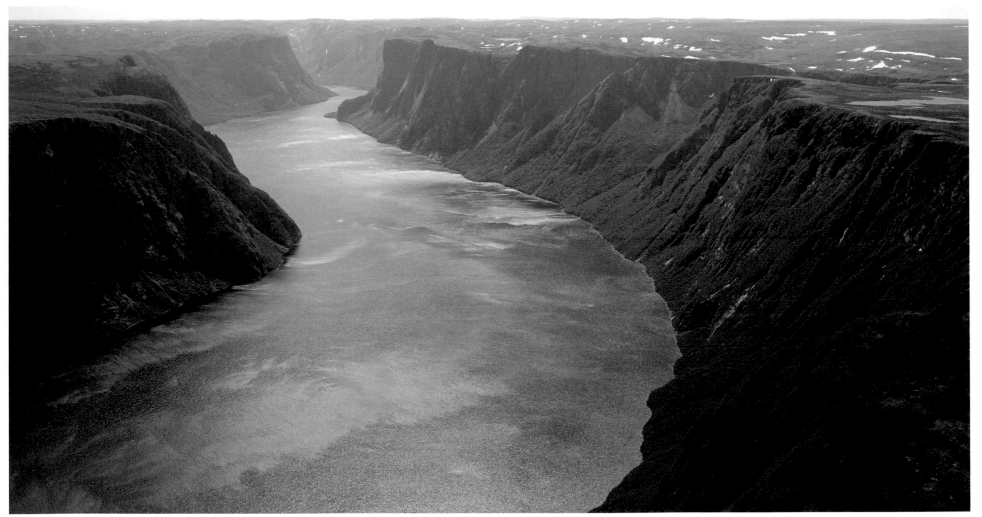

Western Brook Pond, Gros Morne National Park, Newfoundland and Labrador

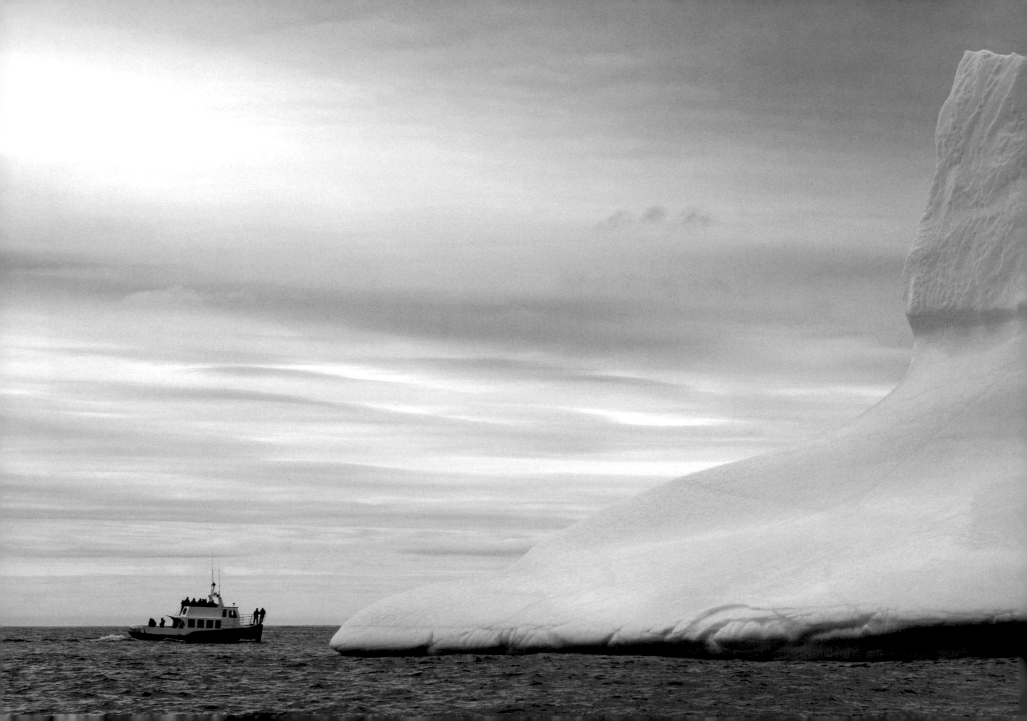

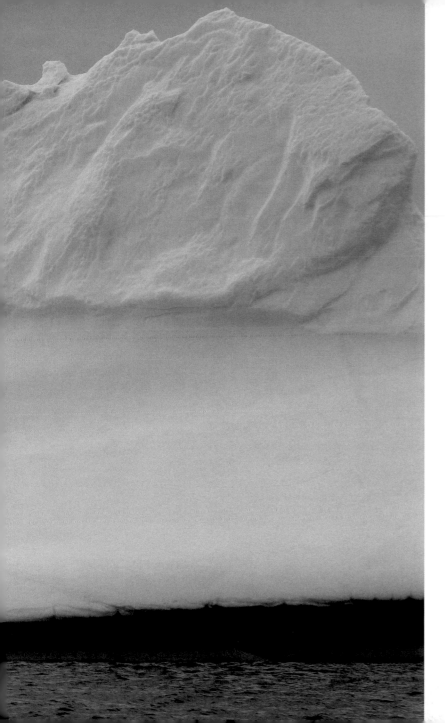

Whether we say it in French with a Saguenay accent or in English with an accent from Newfoundland, and wherever we come from or wherever we live, we all share the most precious heritage that can be given to humankind — our Canadian citizenship.

KIM CAMPBELL, FORMER PRIME MINISTER OF CANADA

Massive iceberg at the tip of the Great Northern Peninsula
near St. Anthony, Newfoundland and Labrador

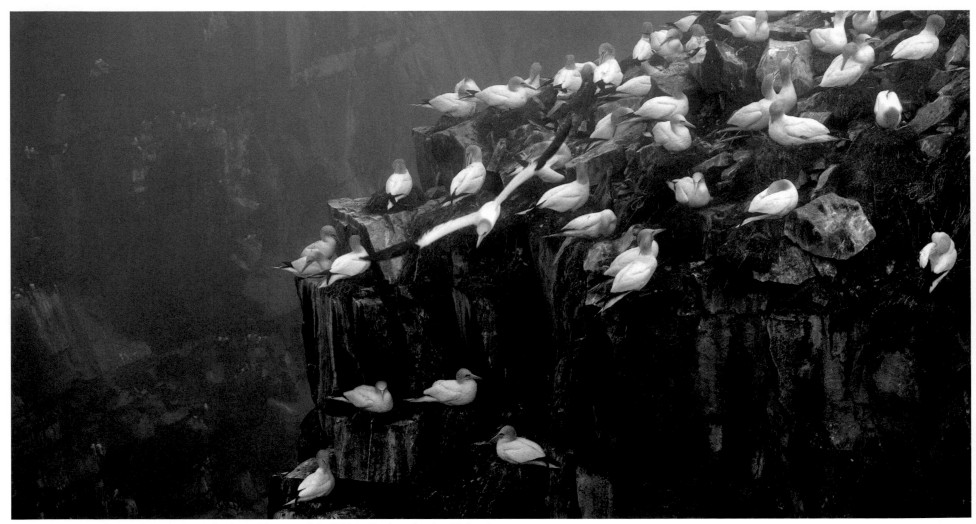

Northern gannet rookery at Cape St. Mary's Ecological Reserve, Saint Bride's, Newfoundland and Labrador

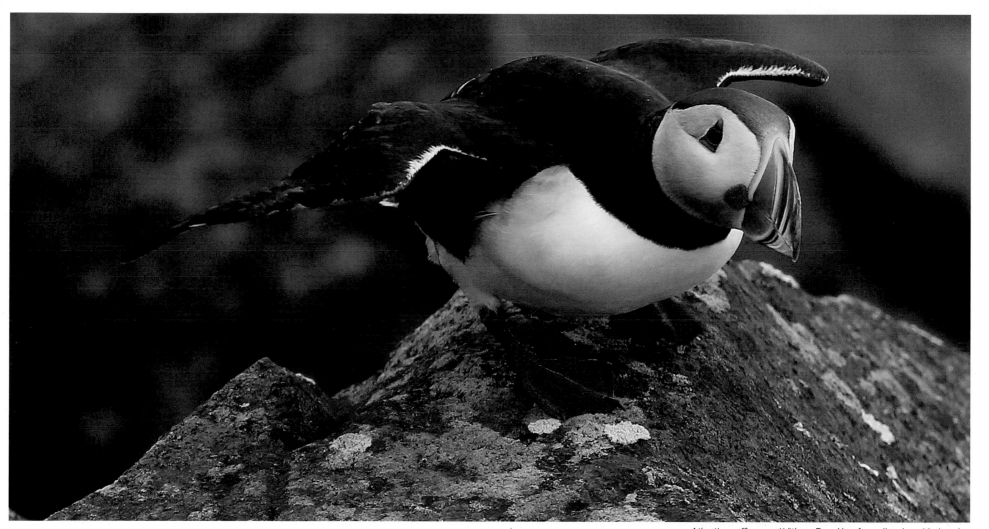

Atlantic puffin near Witless Bay, Newfoundland and Labrador

GEORGE FISCHER

George Fischer is one of Canada's most renowned and prolific landscape photographers. He has produced over 50 books, 50 art posters, and numerous prints. George's work has appeared on the covers of countless international magazines and newspapers, and in the promotional publications of tourism agencies around the world. Two of his recent publications, *Canada in Colour/en couleurs* and *Exotic Places & Faces*, are stunning compilations of his extensive travels. George's book *Unforgettable Canada* was on The *Globe and Mail*'s bestseller list for eight weeks and sold over 50,000 copies. Other titles in the Unforgettable series include: *Unforgettable Tuscany & Florence, Unforgettable Paris Inoubliable, Unforgettable Atlantic Canada, The 1000 Islands – Unforgettable,* and *Les Îles de la Madeleine Inoubliables*. Currently George is working on a few new books including *Faroe Islands – The Light That Never Fades*. He resides in Toronto, Canada.

See more of George Fischer's work at georgefischerphotography.com

ACKNOWLEDGMENTS

Special thanks to Jean Lepage, Reginald Poirier, and Evan Quick who join me on my quests, keep me grounded, and provide valuable assistance with equipment.

For being a key part of my team and making things happen, I am grateful to my talented art director, Catharine Barker.

Îles de la Madeleine, Québec